ANIMAL WOODCUT DESIGNS
COLORING BOOK

Tim Foley

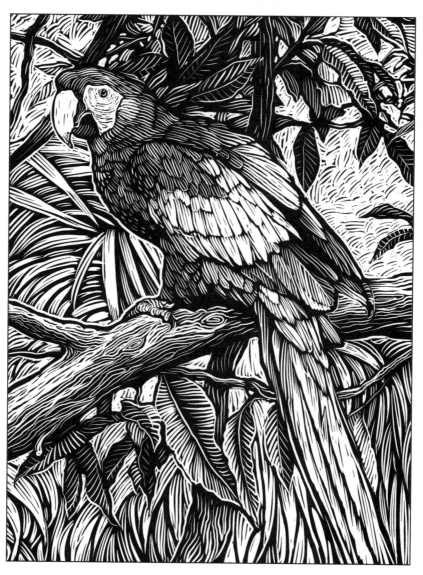

DOVER PUBLICATIONS, INC.
MINEOLA, NEW YORK

These 63 striking animal images, specially designed for advanced colorists, will appeal to animal lovers as well as those who appreciate the dramatic and bold contrasts of woodcut designs. This deluxe edition features animals as small as a delicate butterfly and as large as an immense elephant. There are ocean dwellers such as an eight-armed octopus, a fearsome shark, and a loggerhead sea turtle as well as forest denizens, from a sweet orangutan with her baby to a fierce tiger. Also included in this treasury of animal woodcuts are a rooster, pig, cow, and other farm animals, as well as arctic animals, a variety of birds, and family pets. The black backgrounds on these intricate designs will intensify the effect of the coloring media you use. Plus, the pages are perforated and printed on one side only for easy removal and display.

Bibliographical Note

Animal Woodcut Designs Coloring Book is a new work, published by Dover Publications, Inc., in 2016. It contains a selection of 13 plates from the previously published Dover book by Tim Foley: *Woodcut Designs Coloring Book* (2016).

International Standard Book Number

ISBN-13: 978-0-486-80997-7
ISBN-10: 0-486-80997-8

Manufactured in the United States by RR Donnelley
80997801 2016
www.doverpublications.com

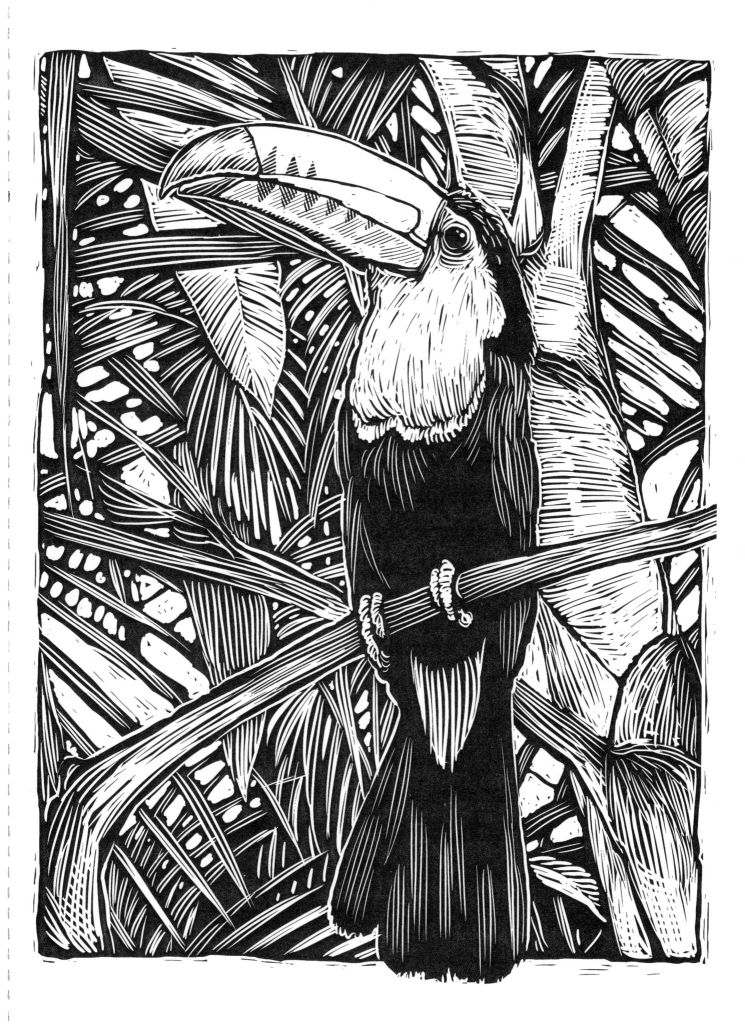

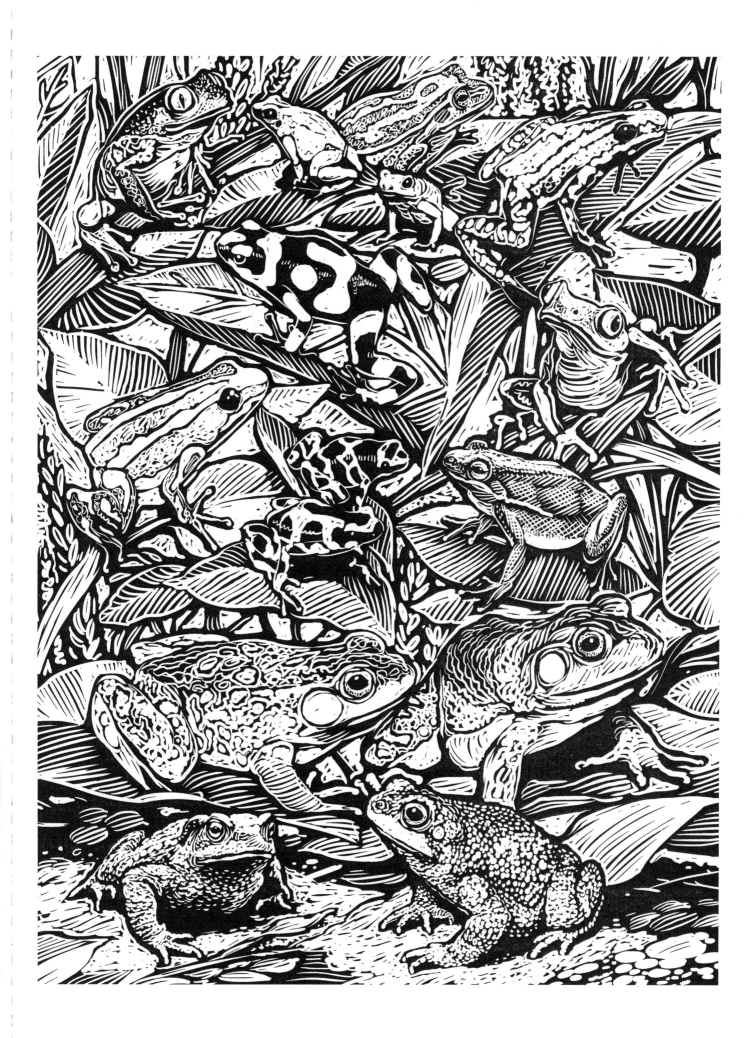

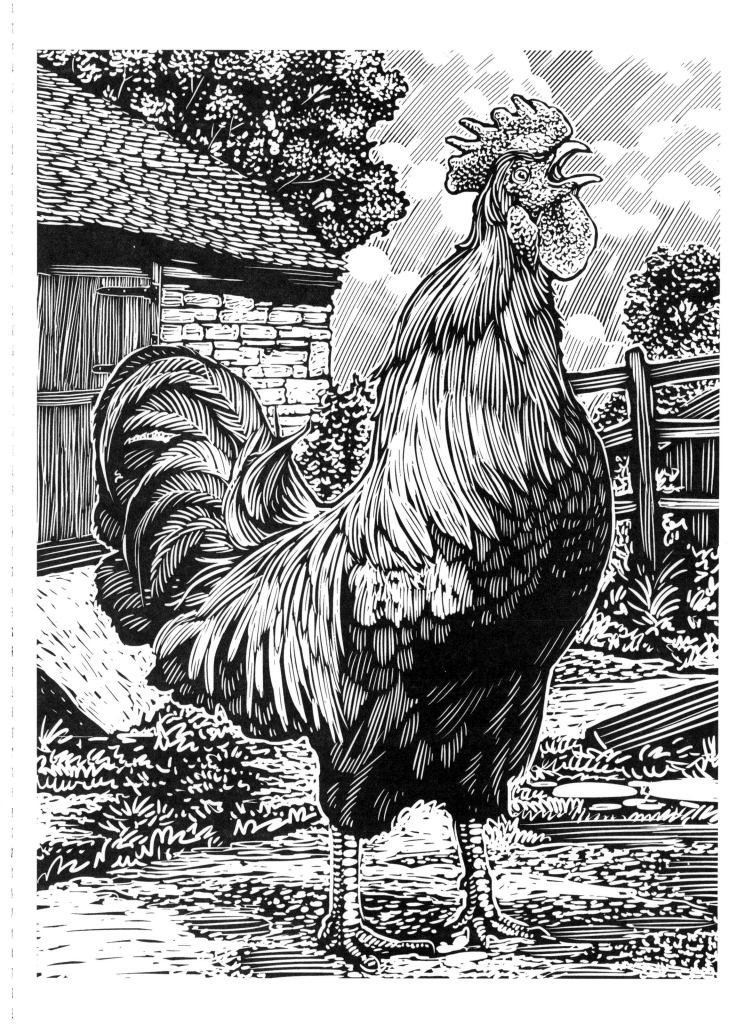

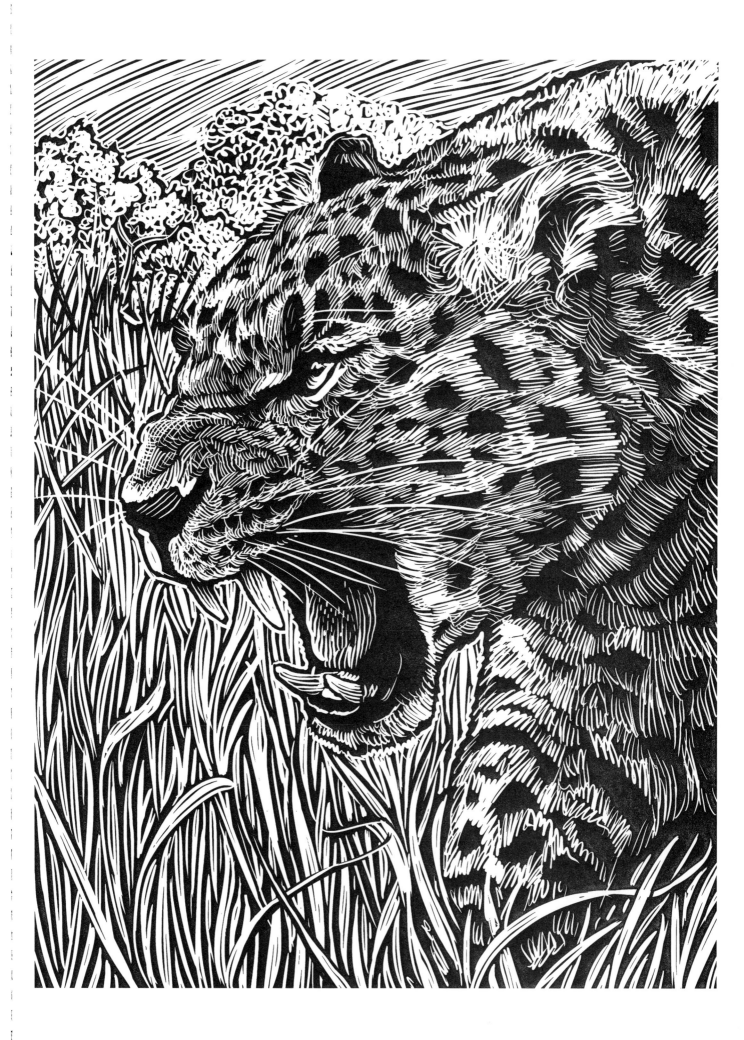

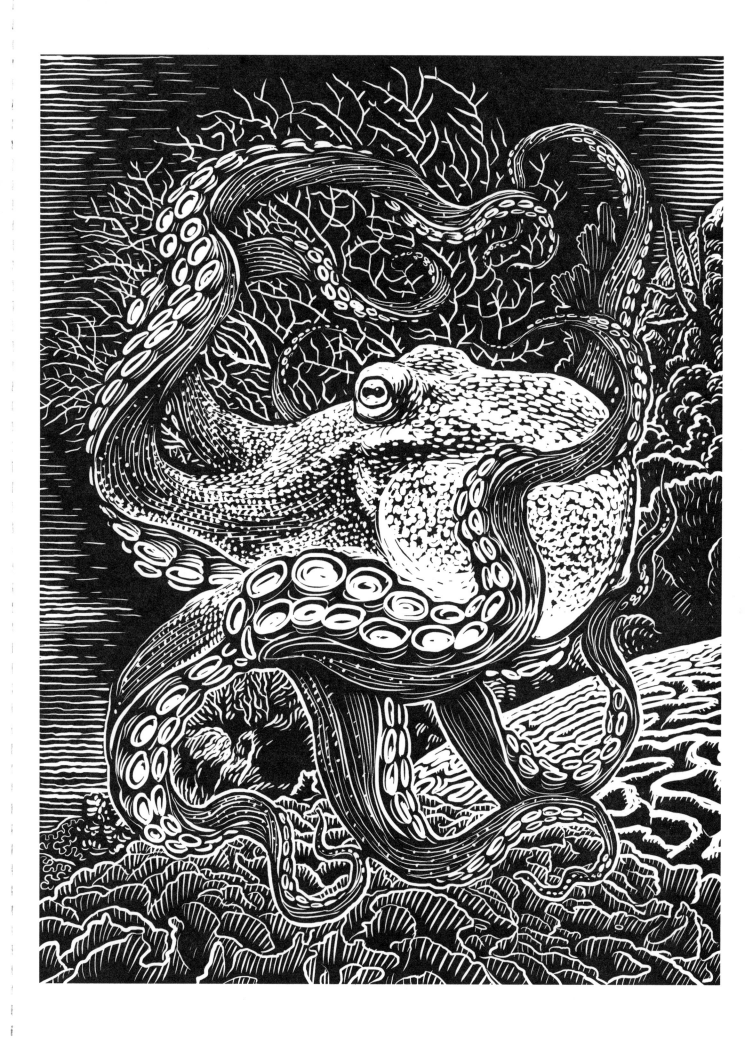

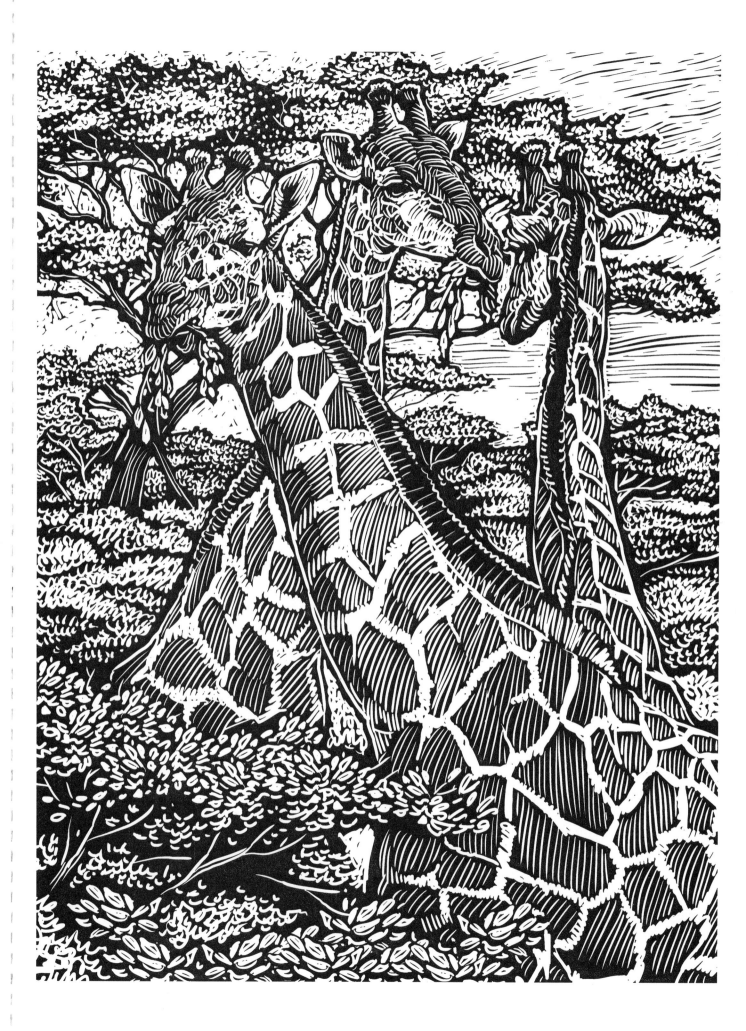

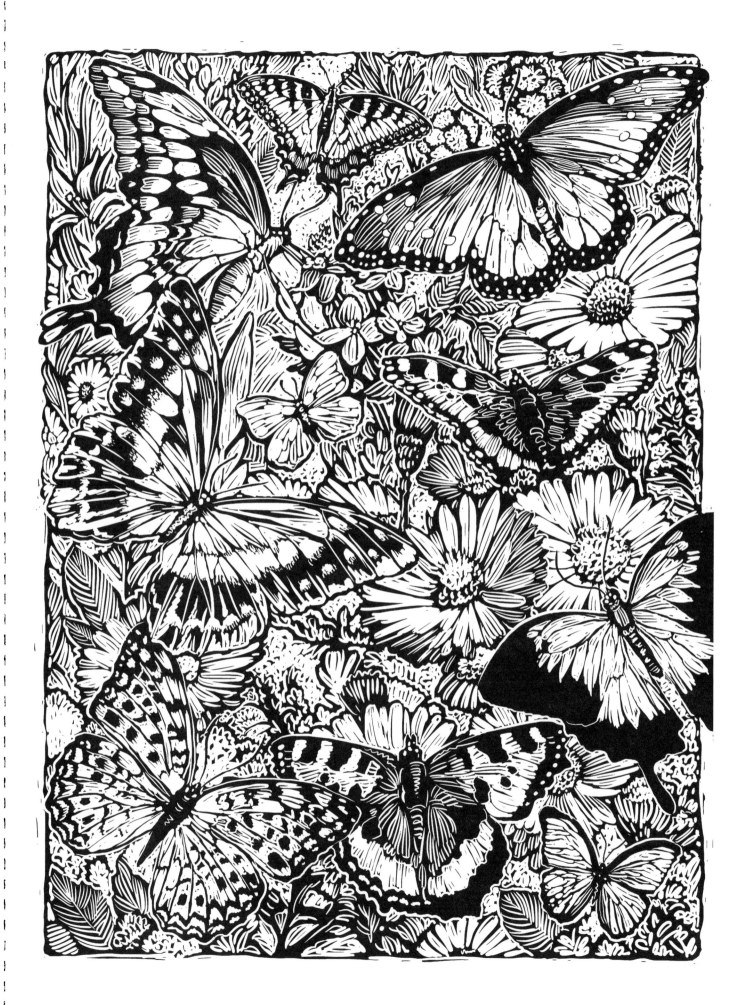

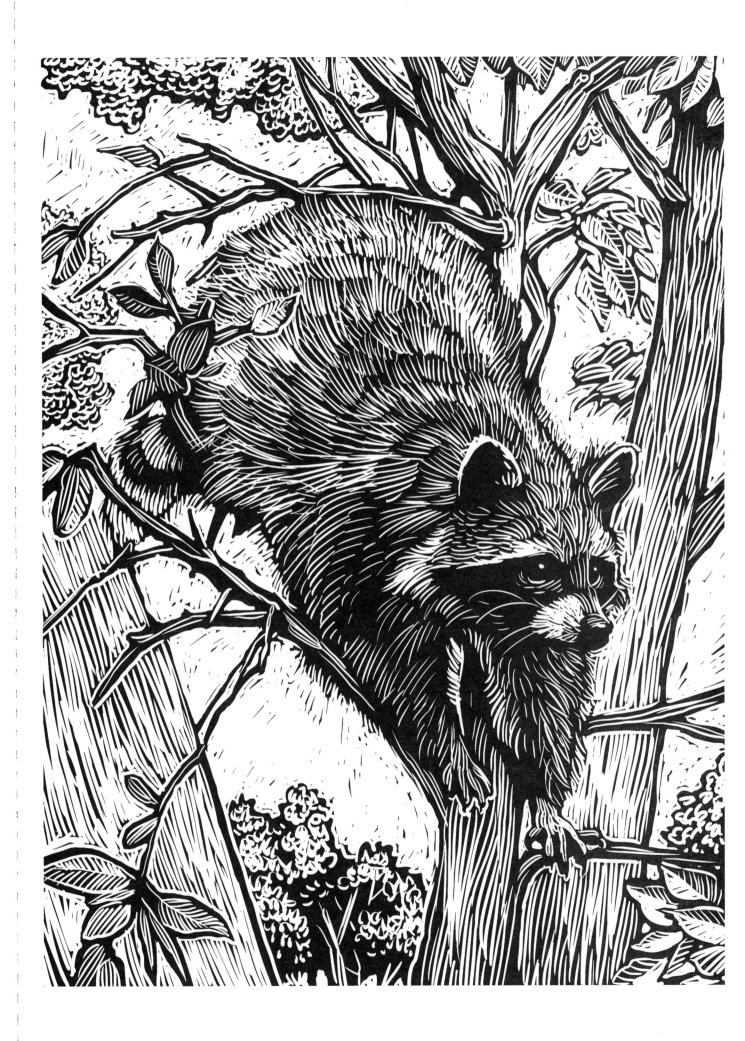

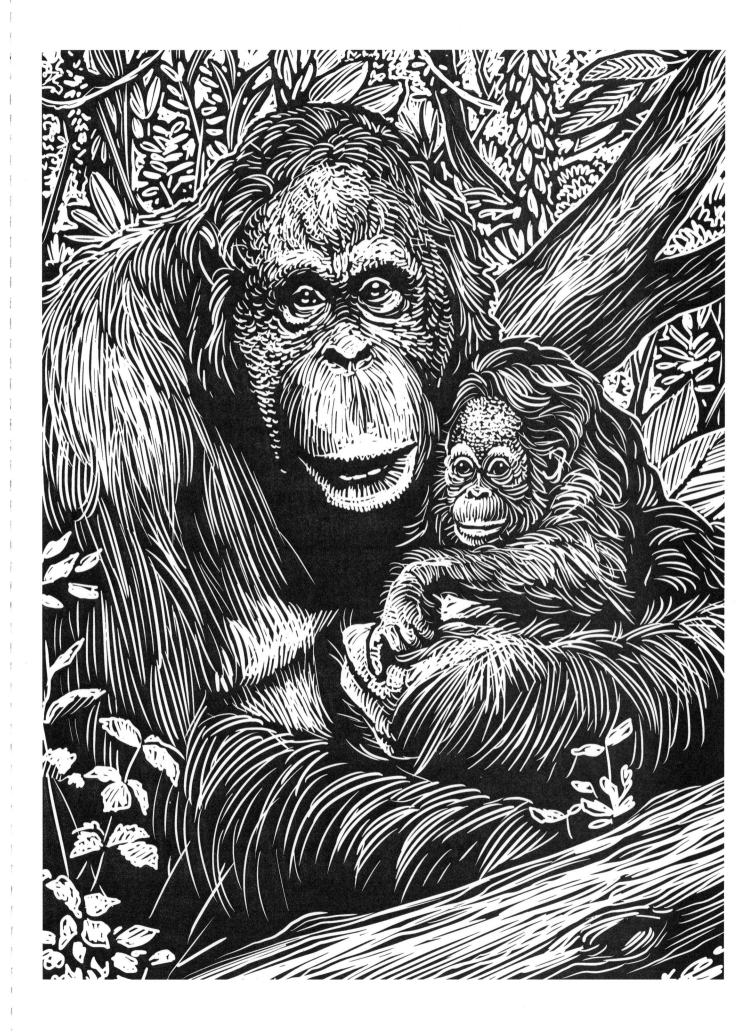

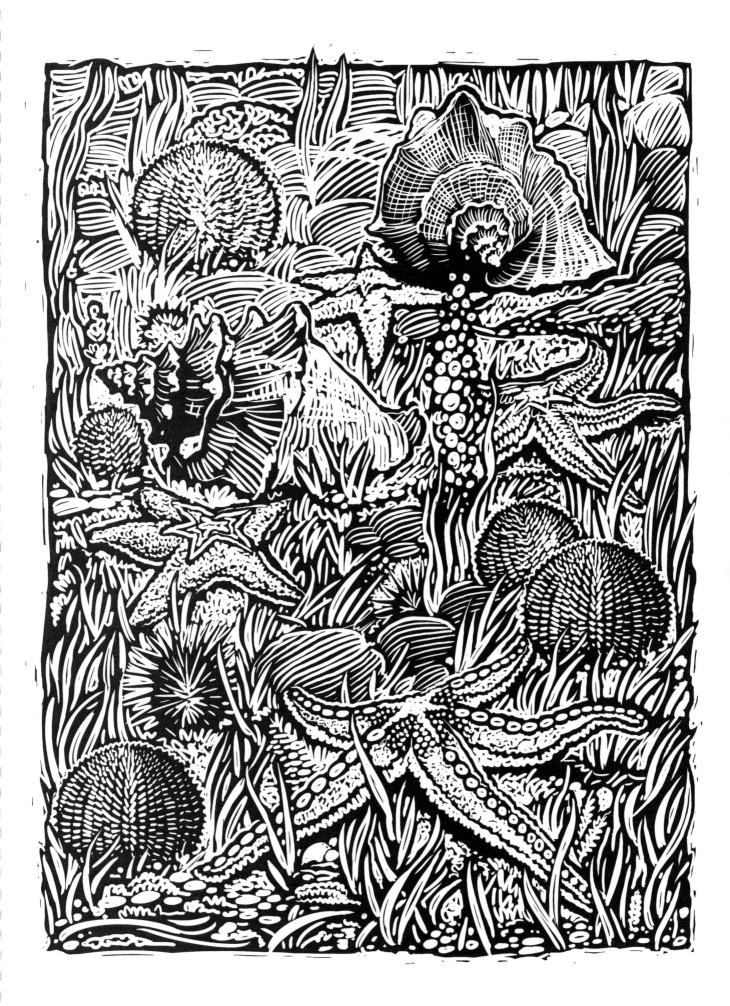

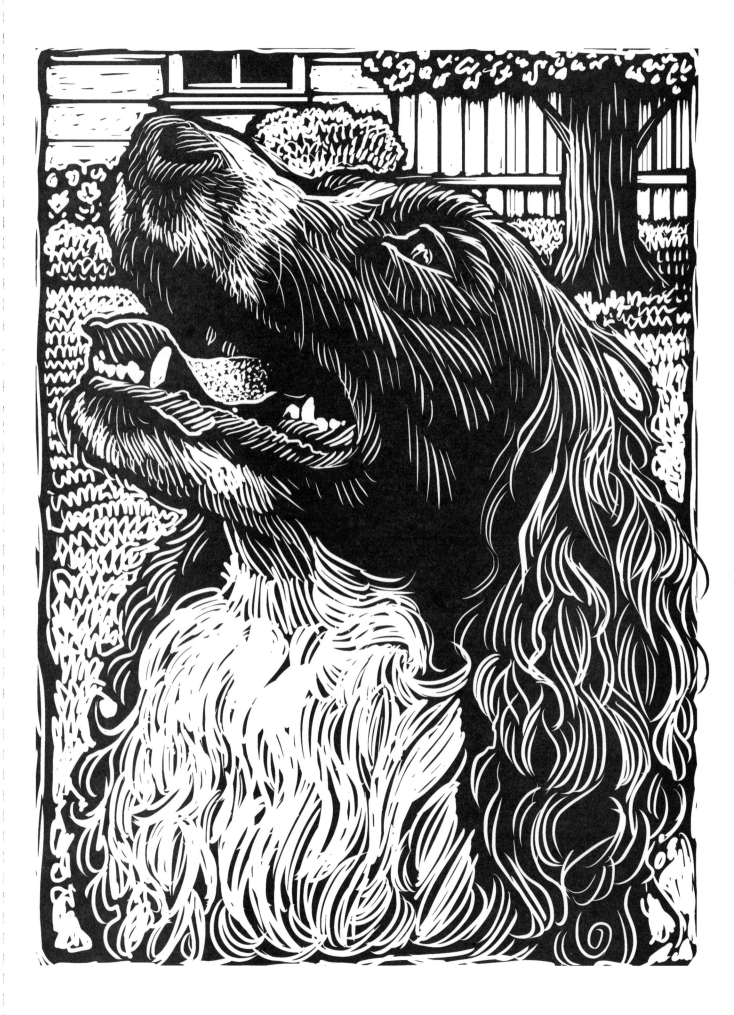

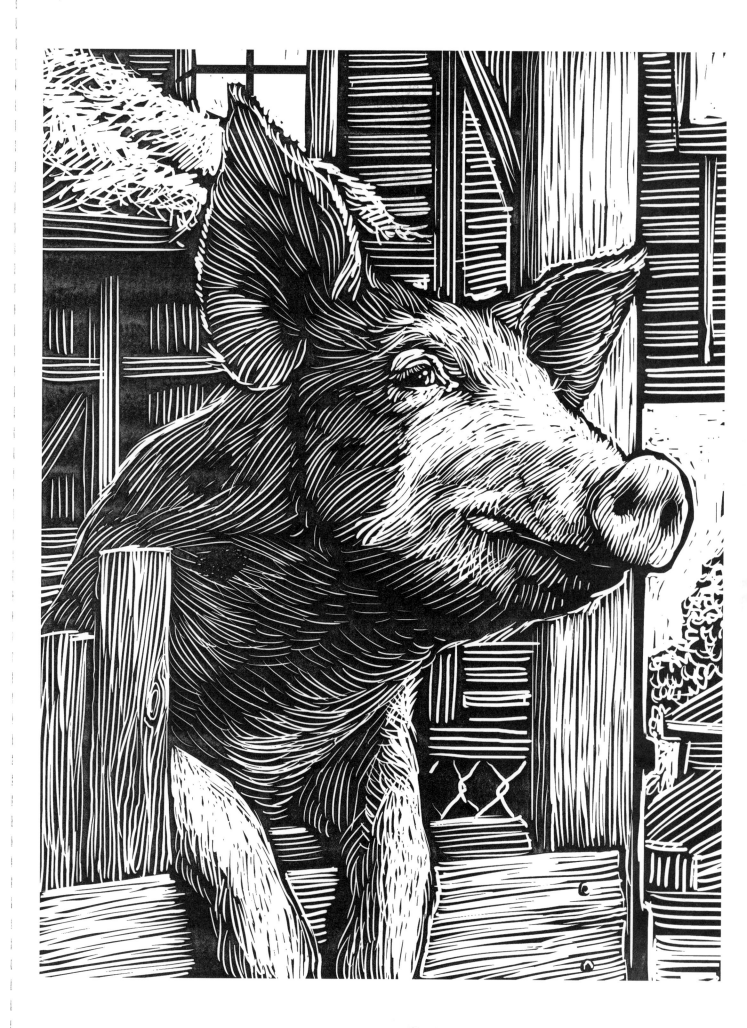

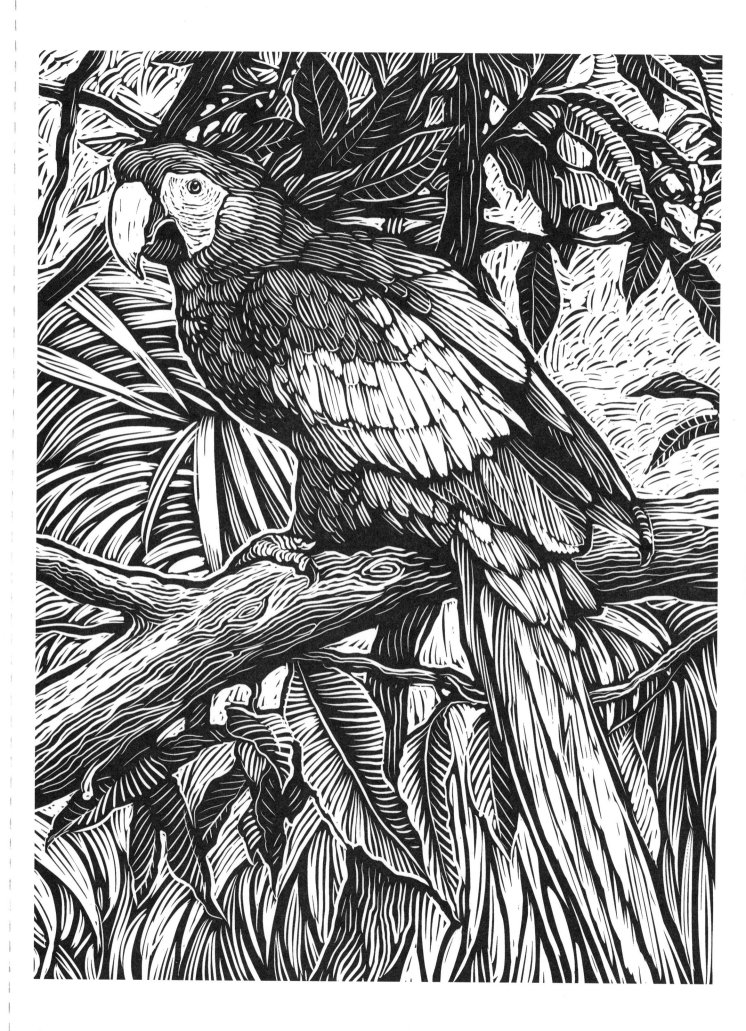

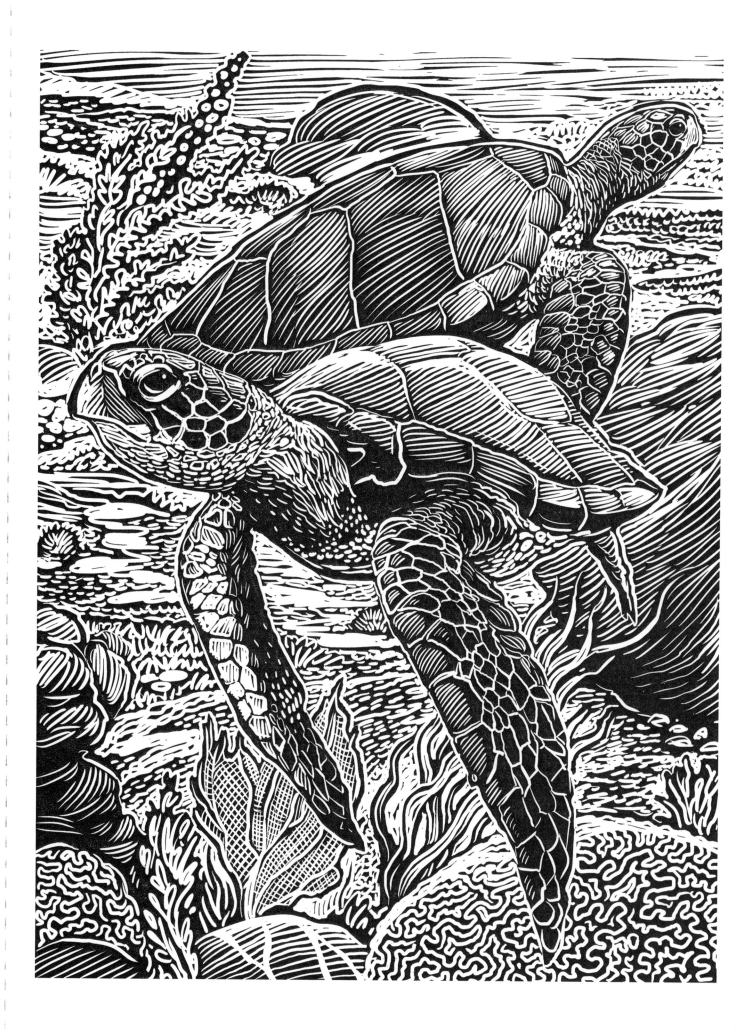

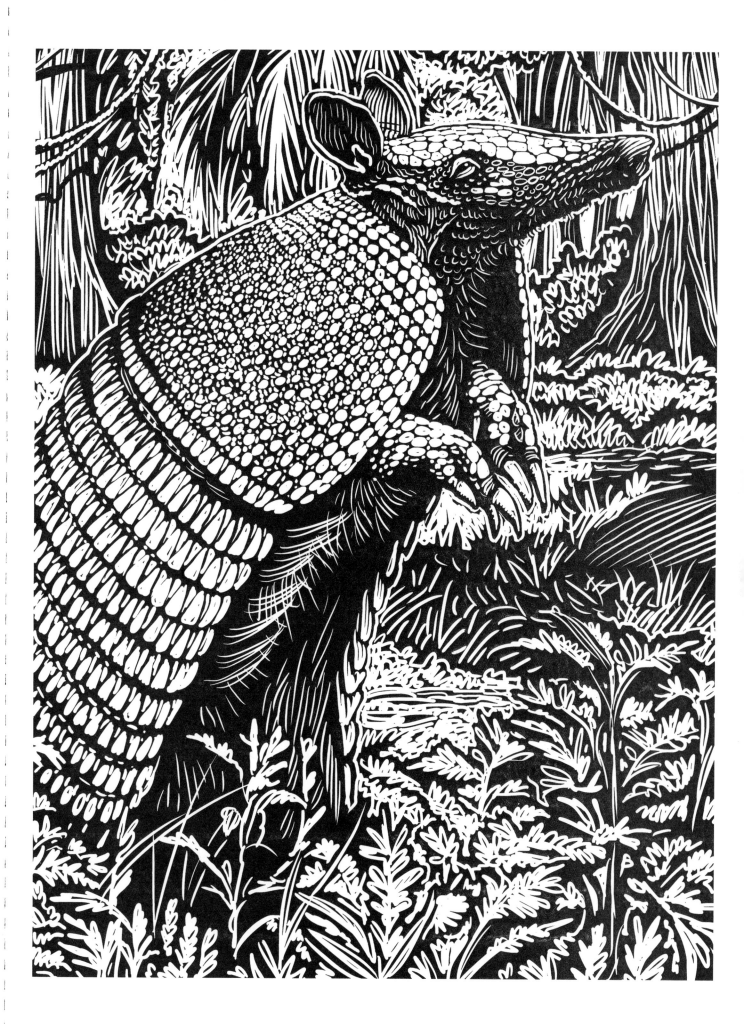

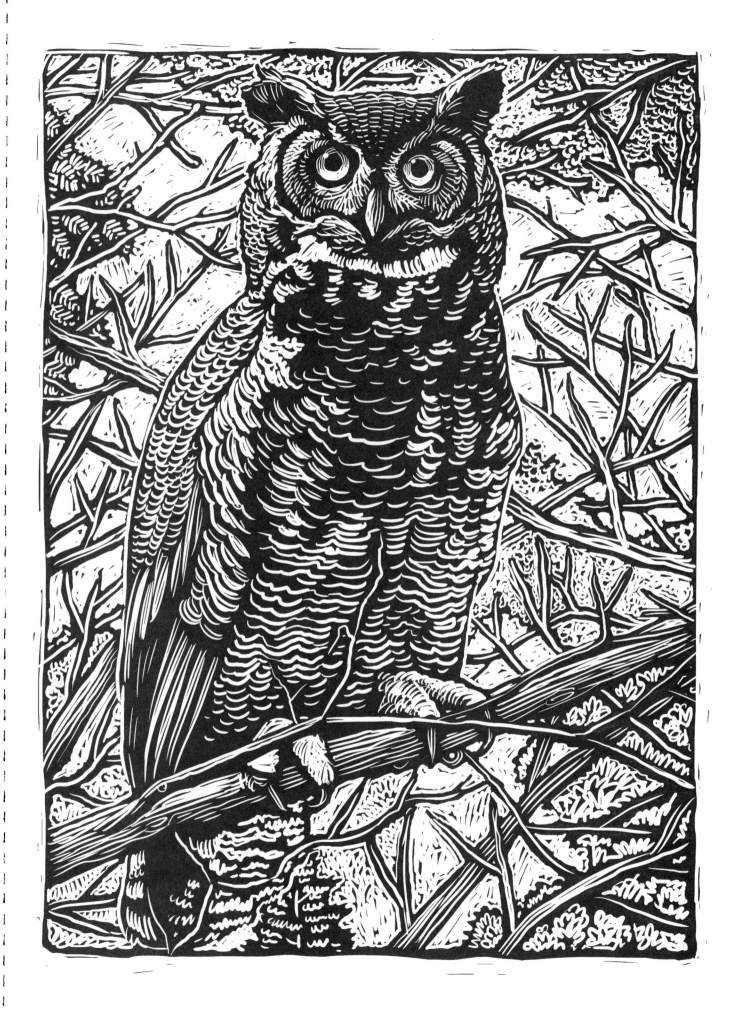

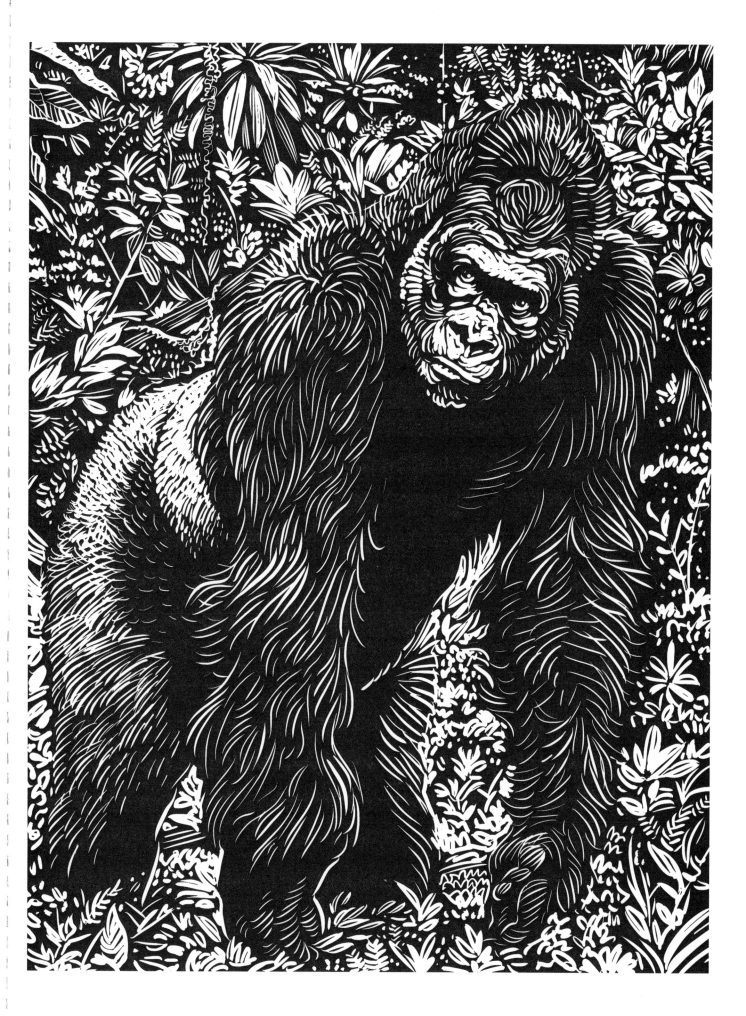

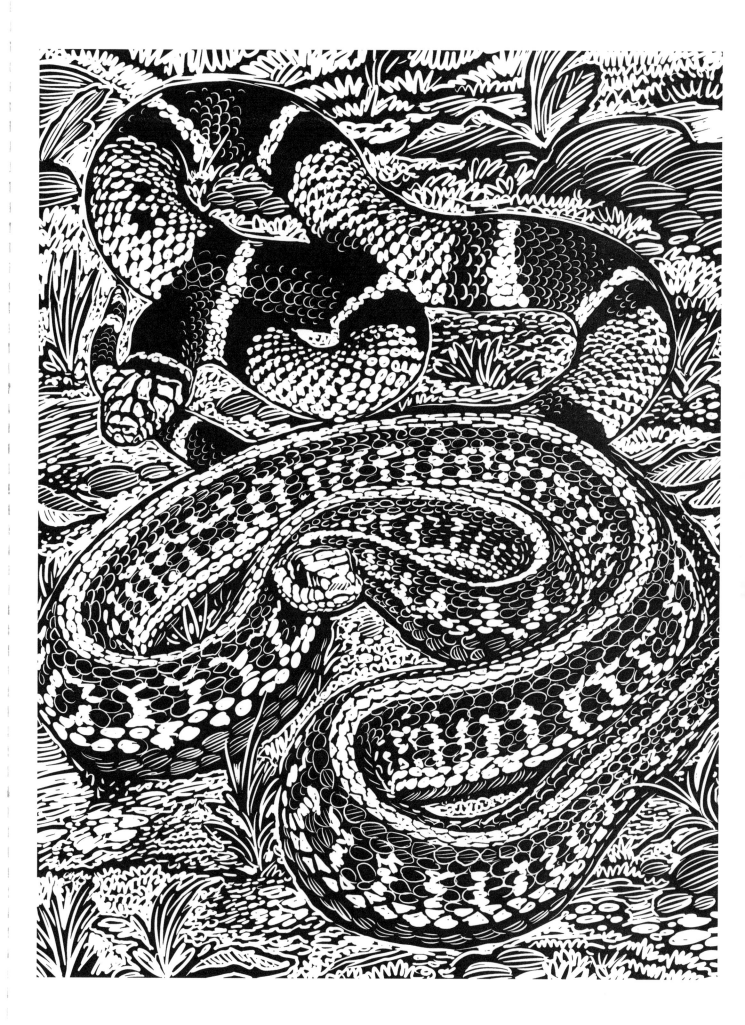

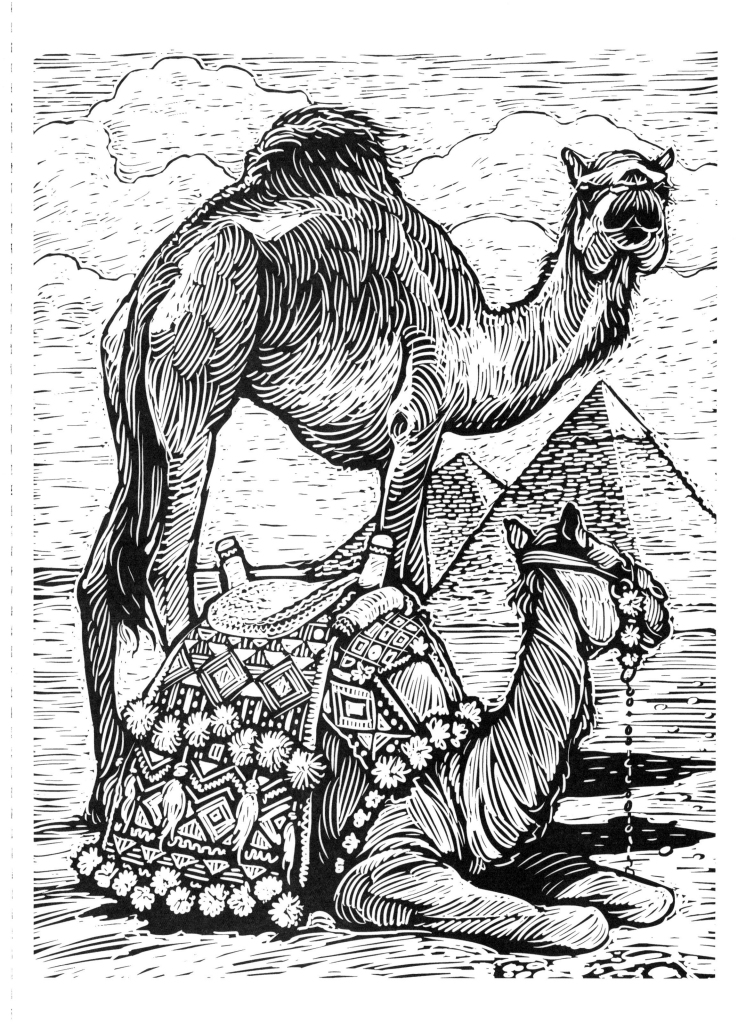

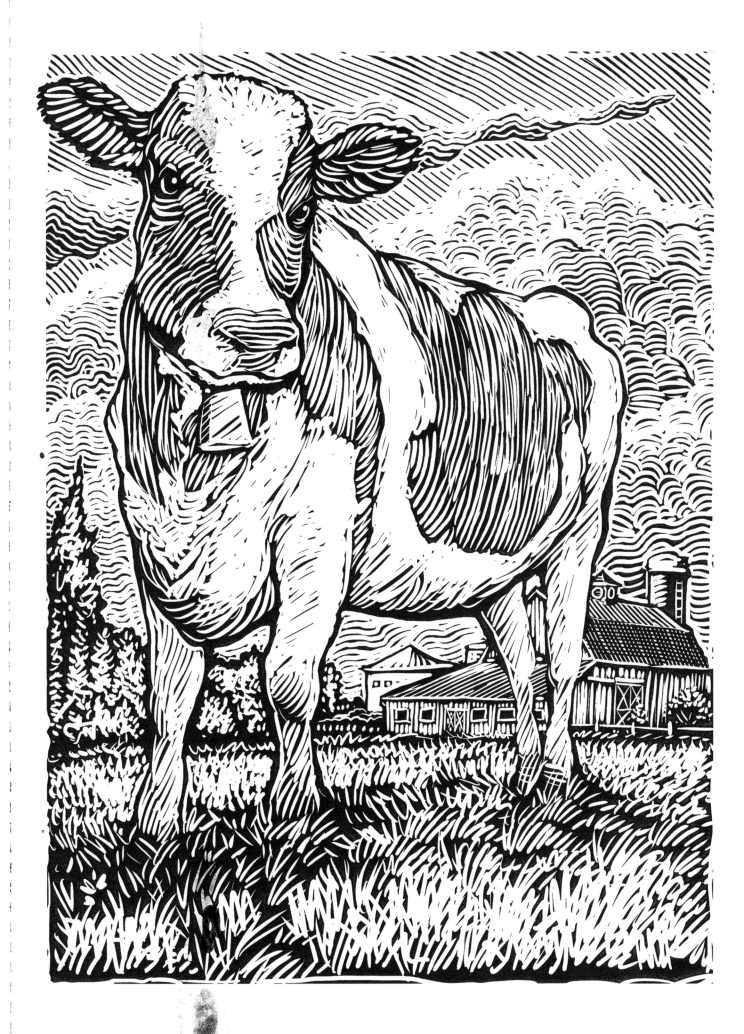

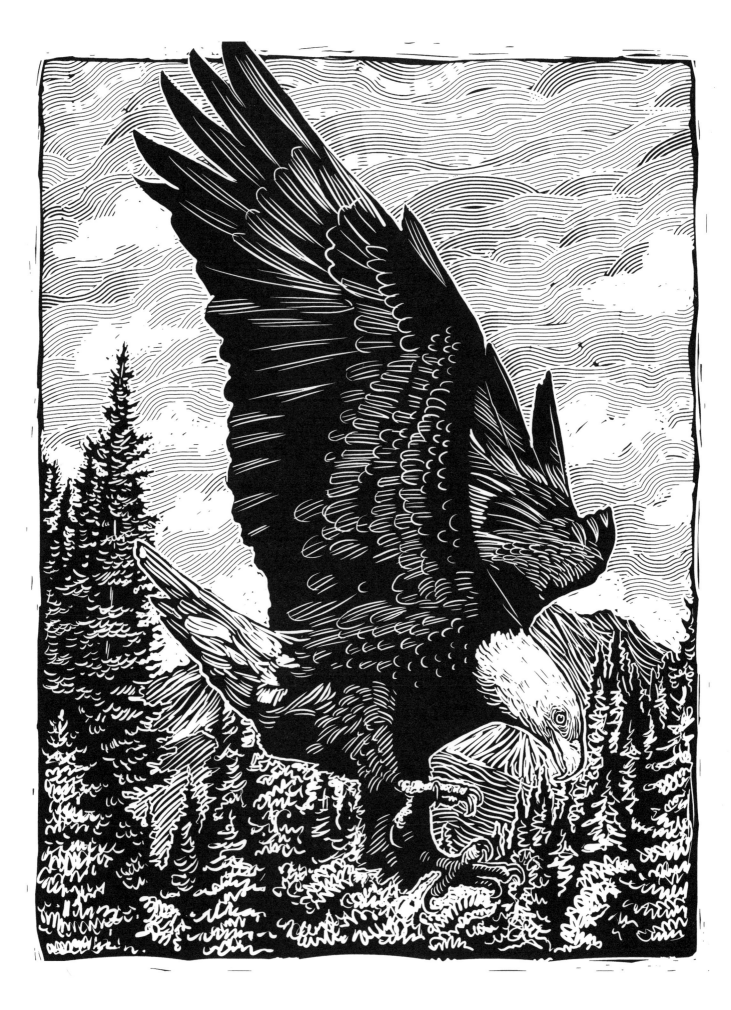

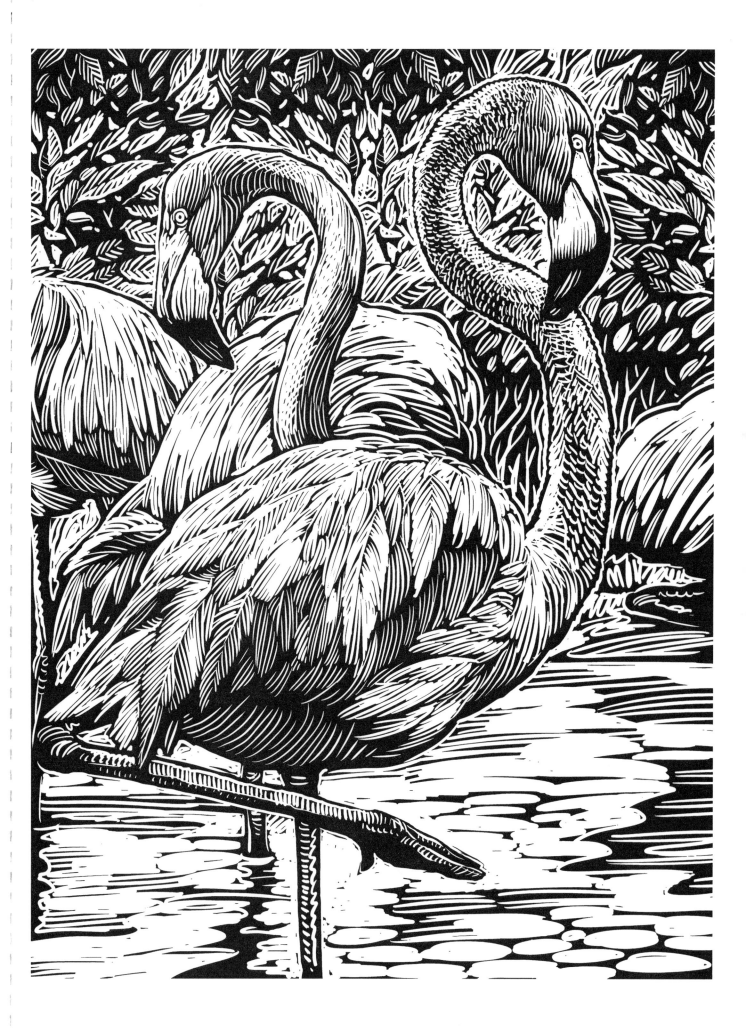

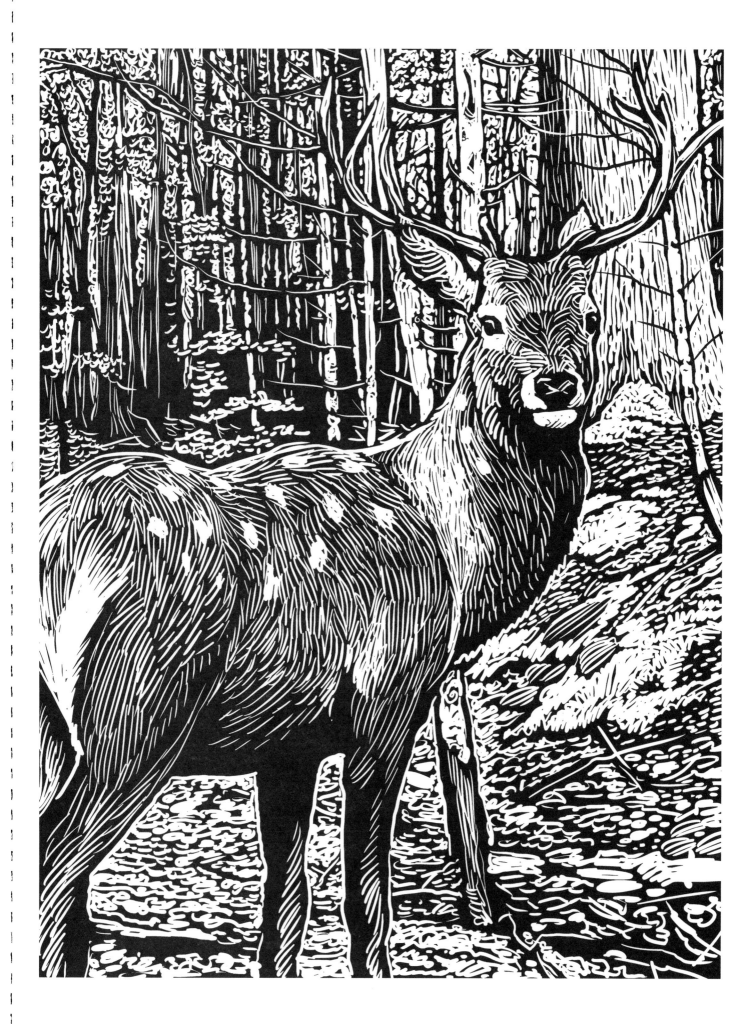

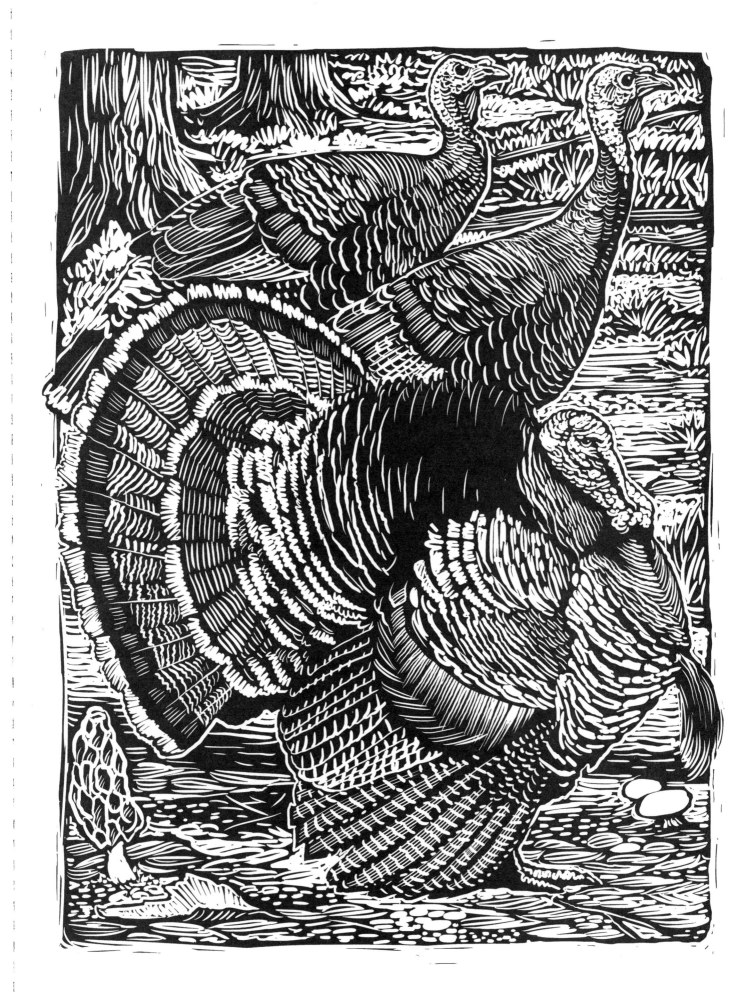

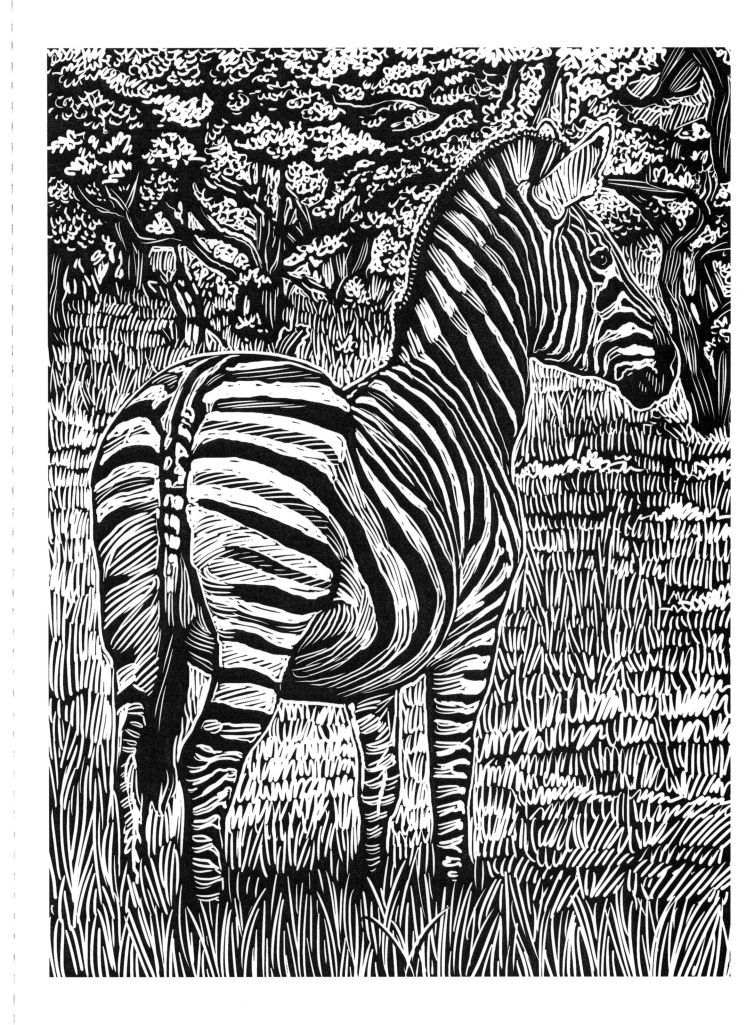

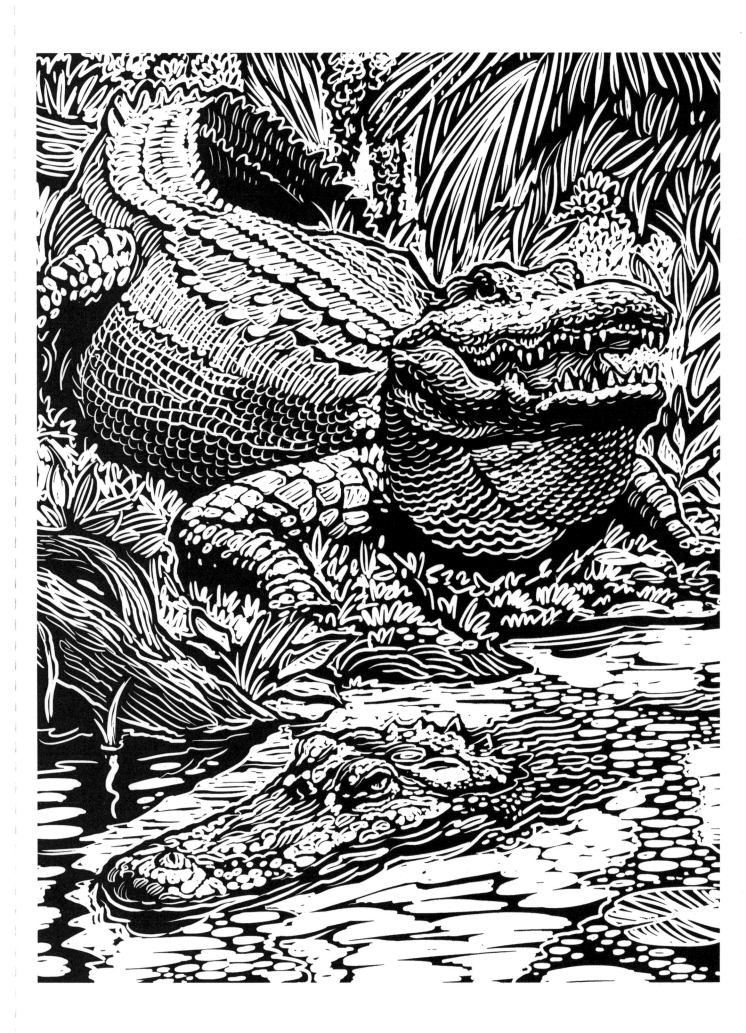

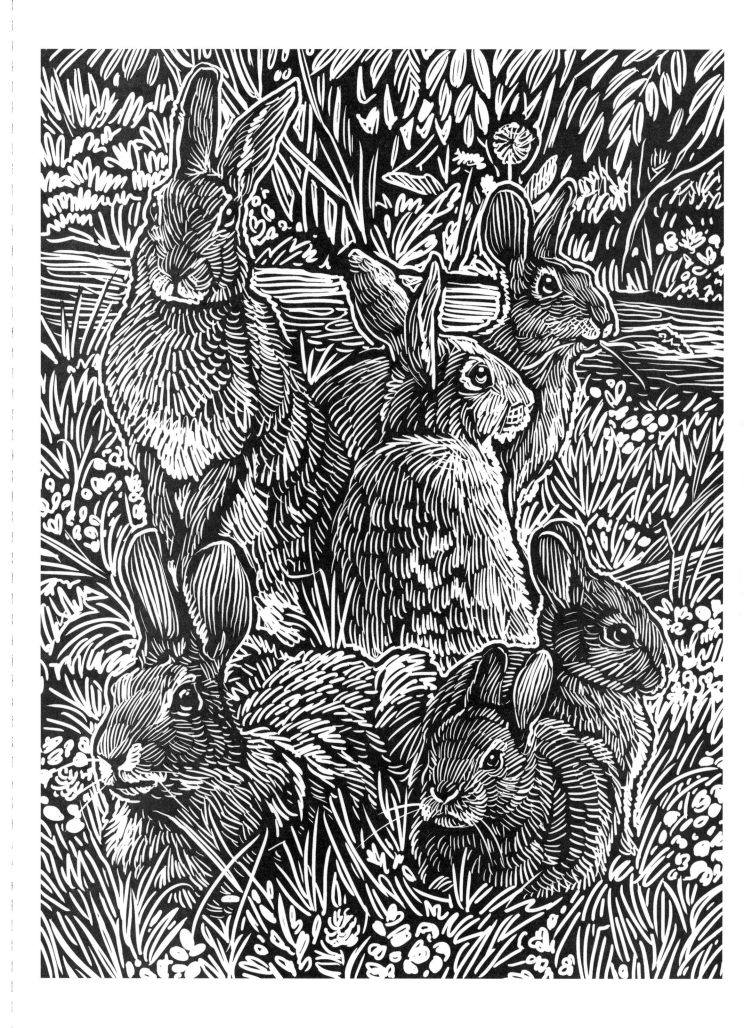

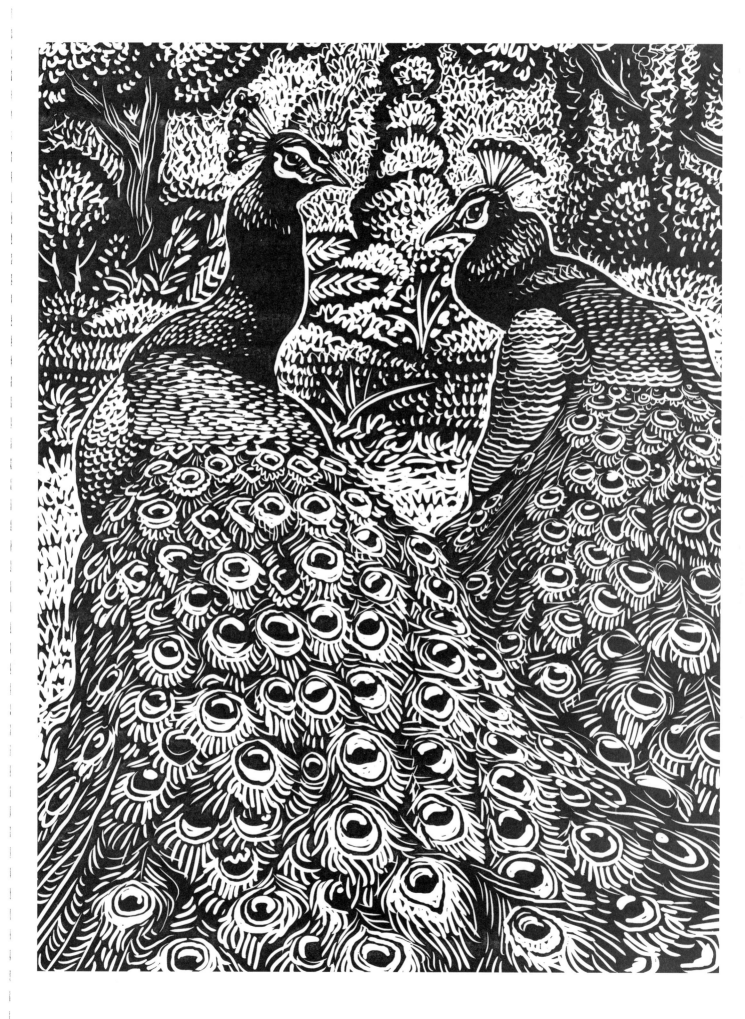

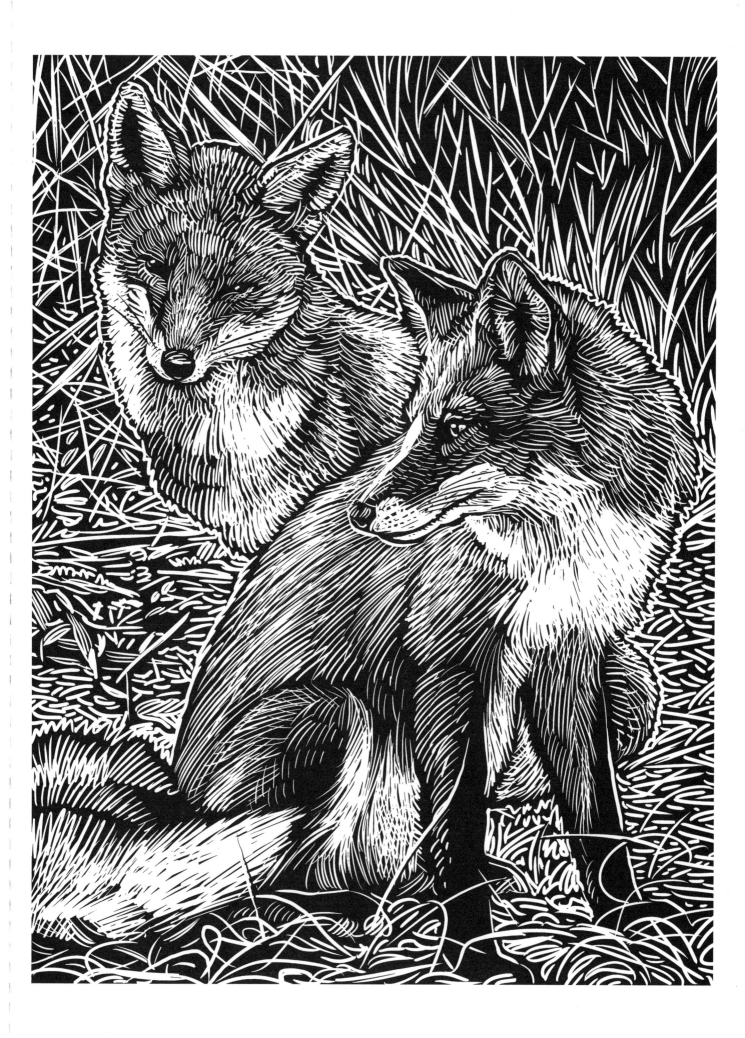

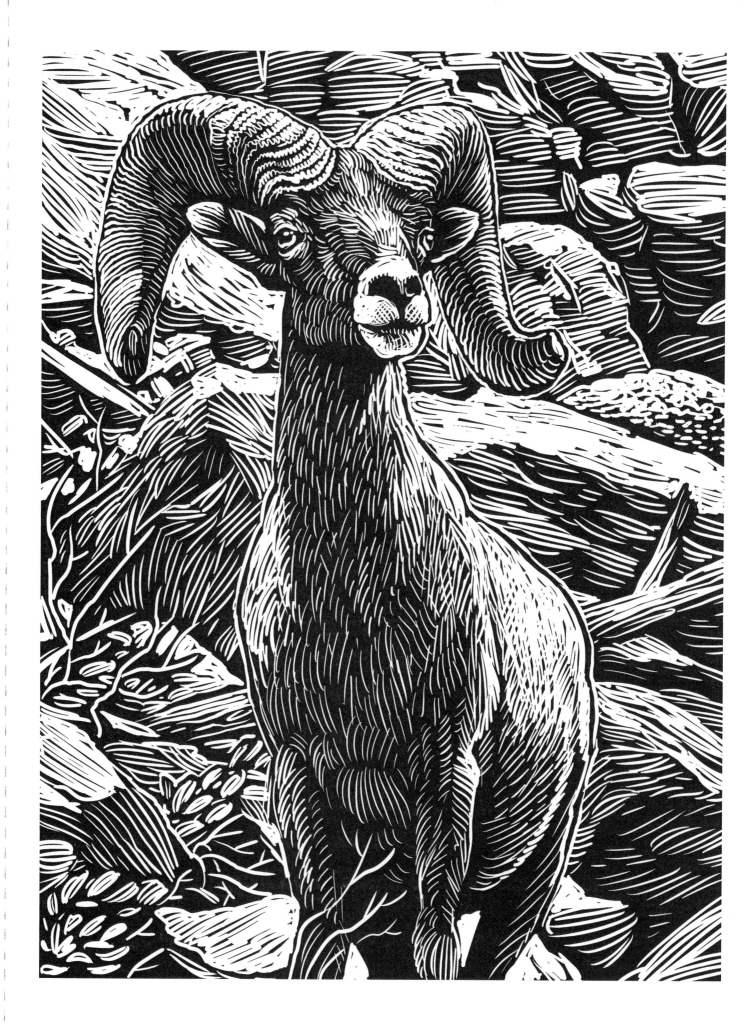

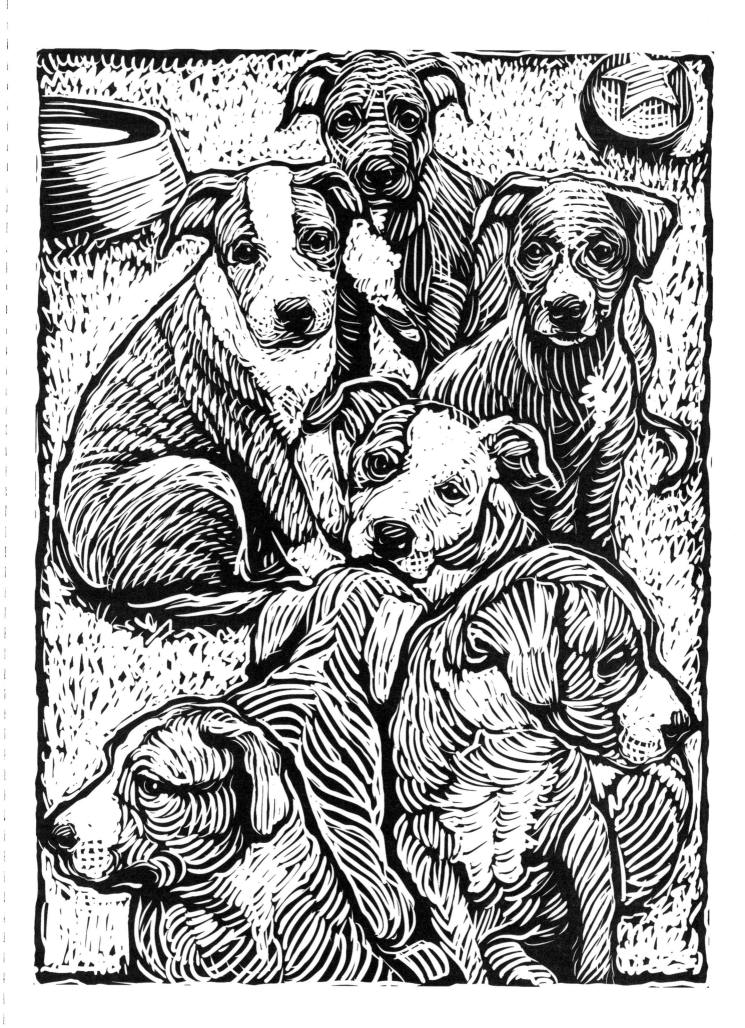

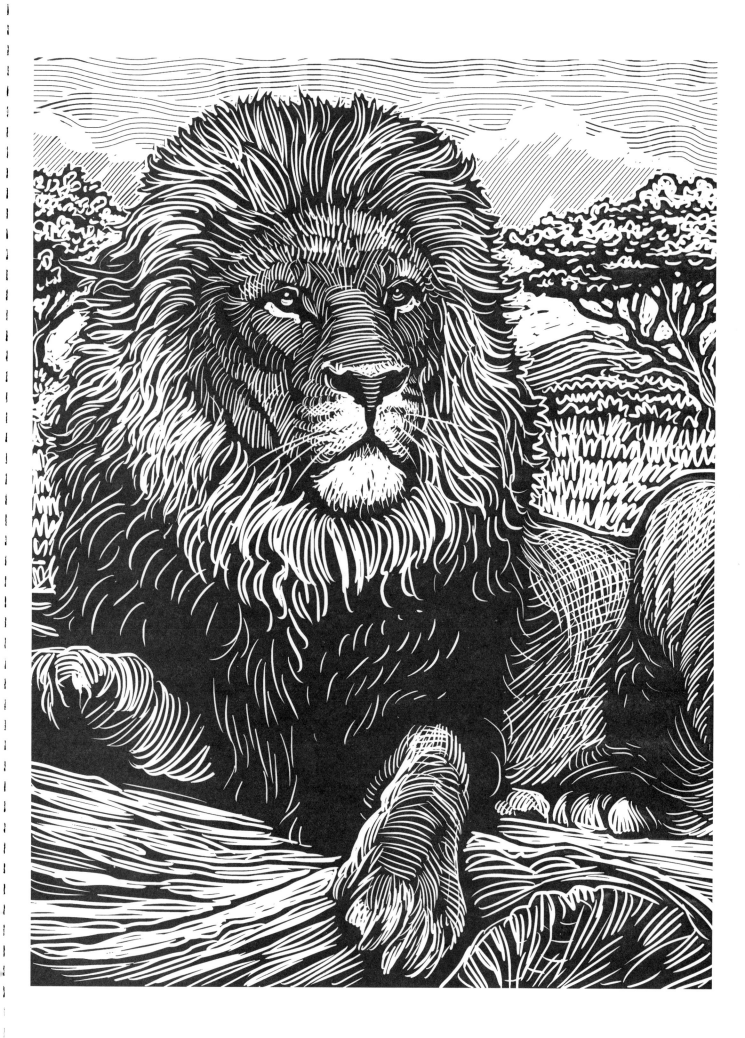

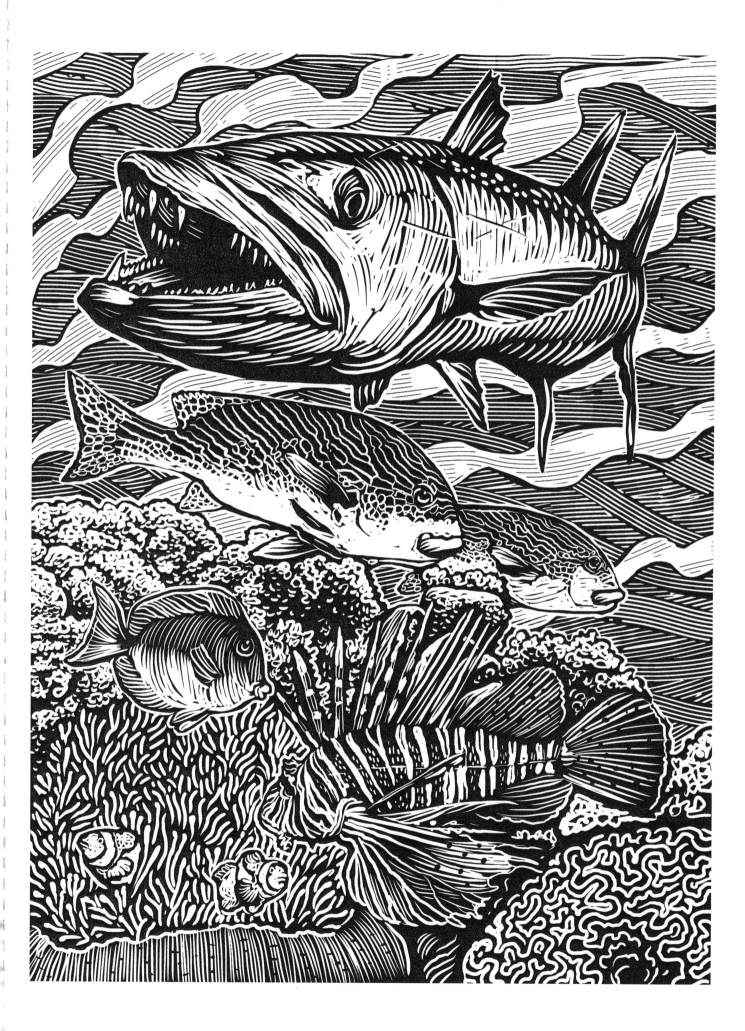

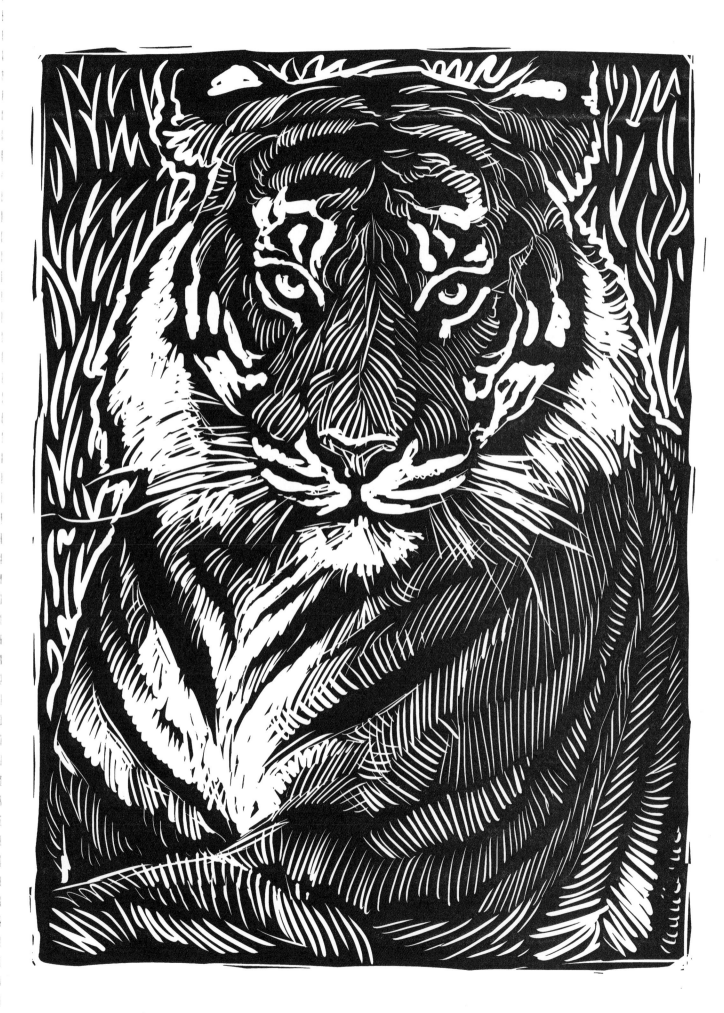

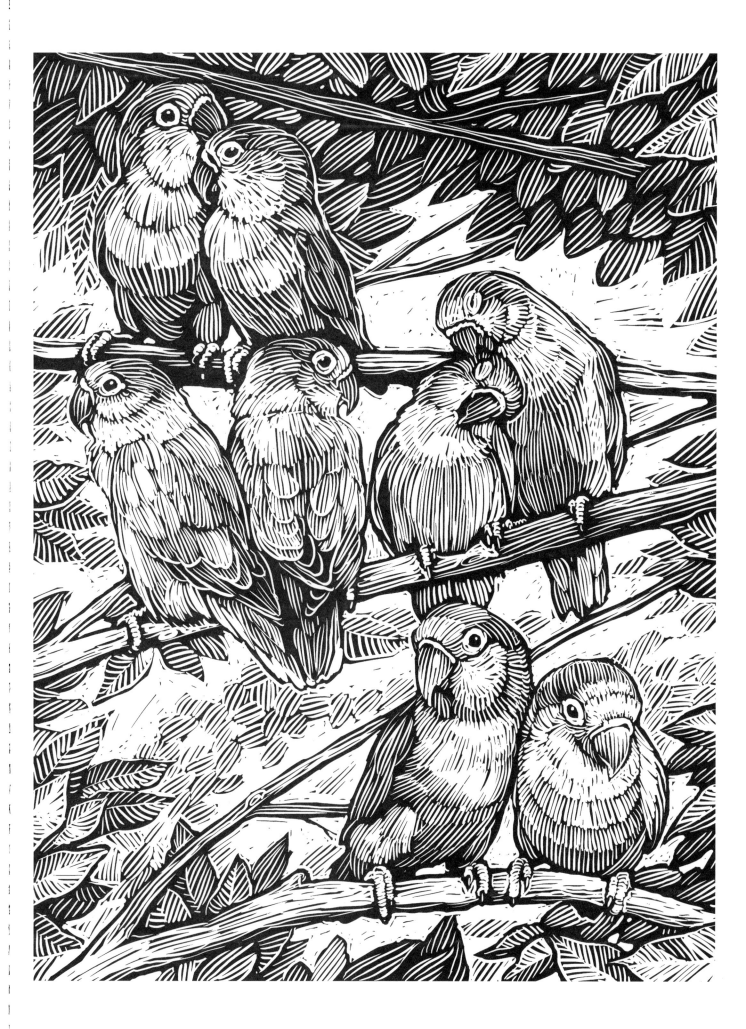

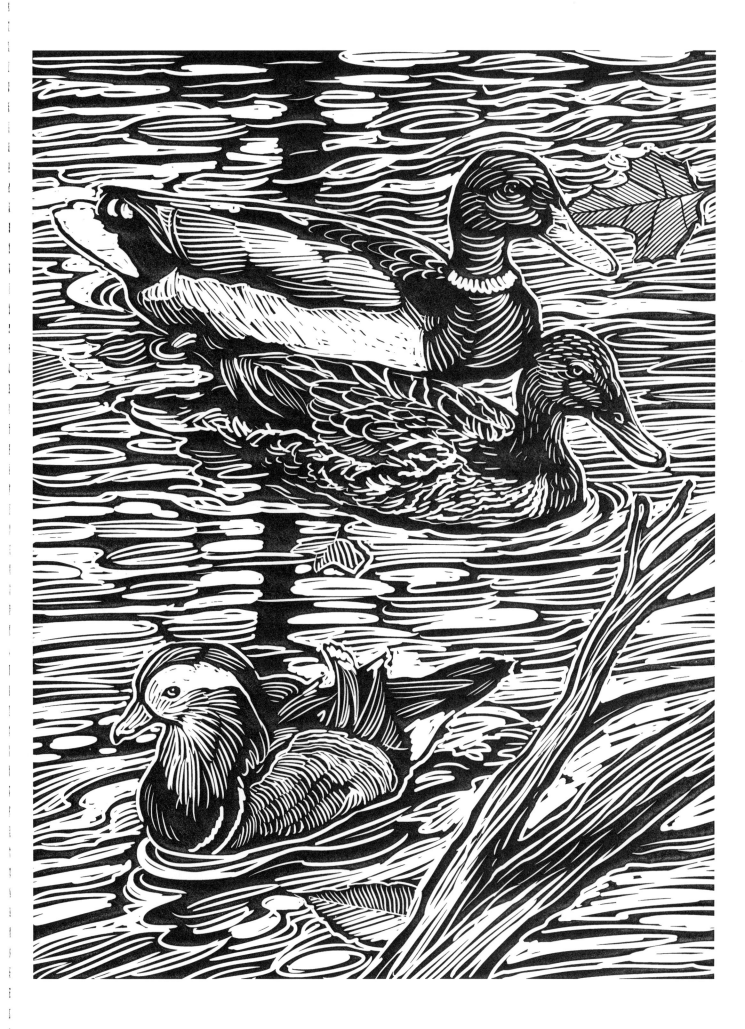

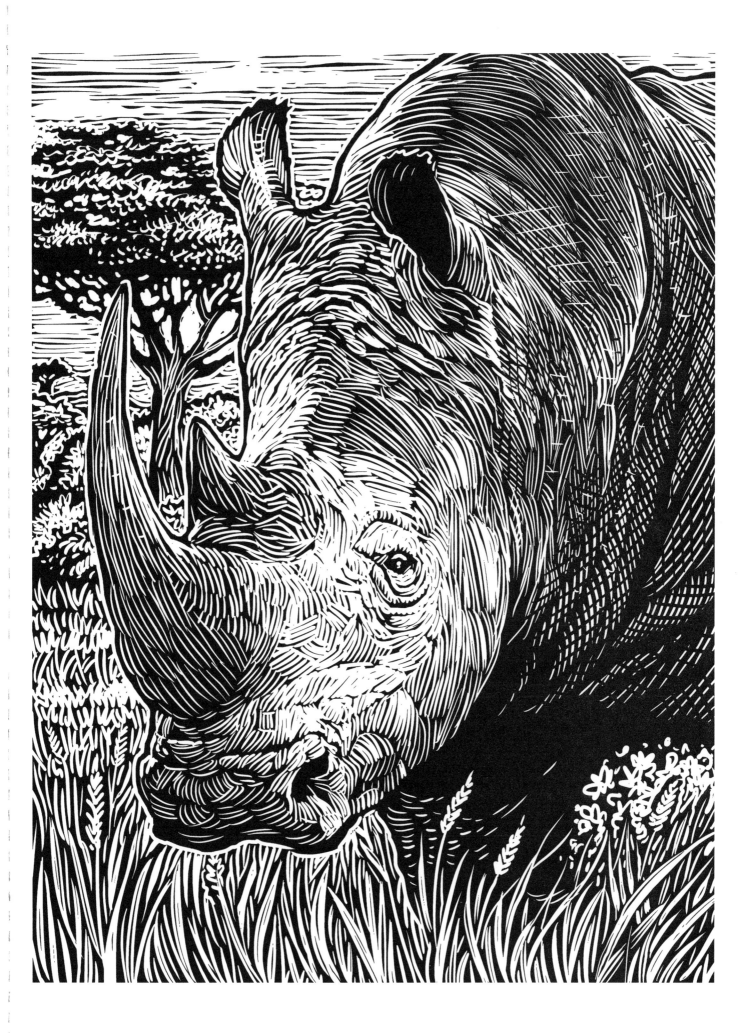

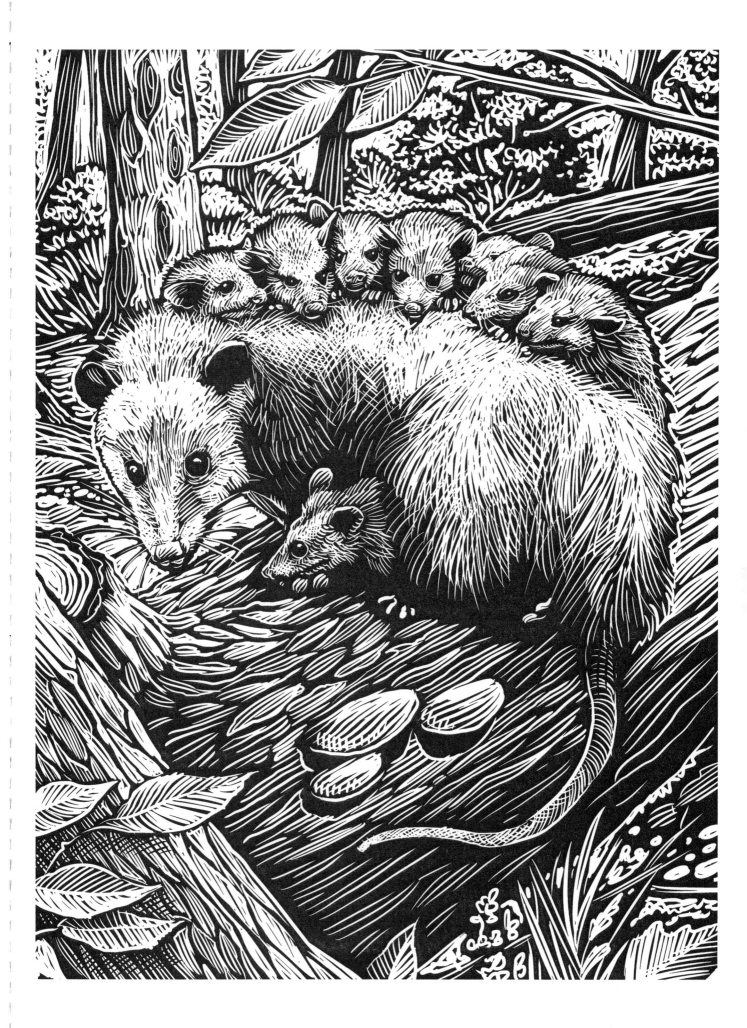

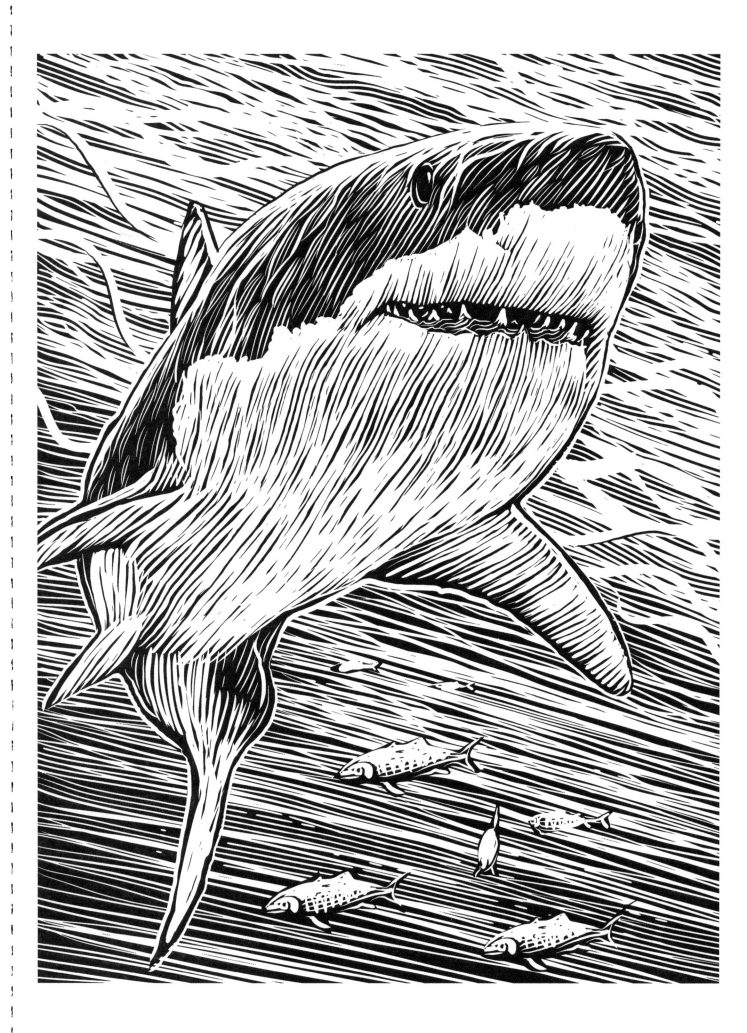

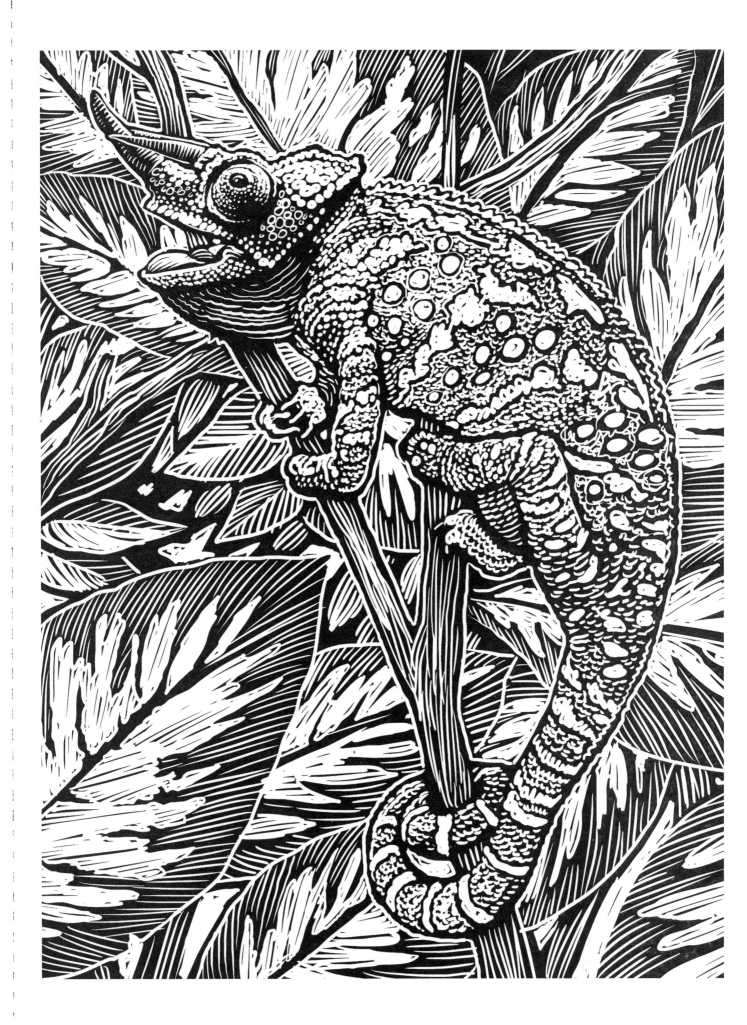

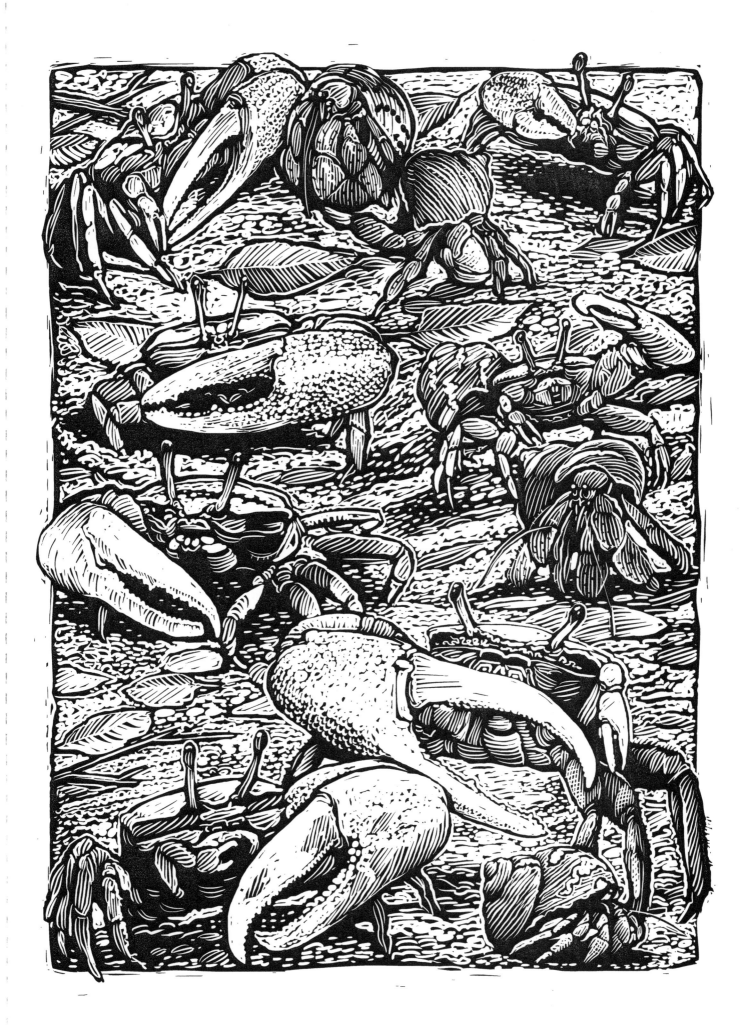

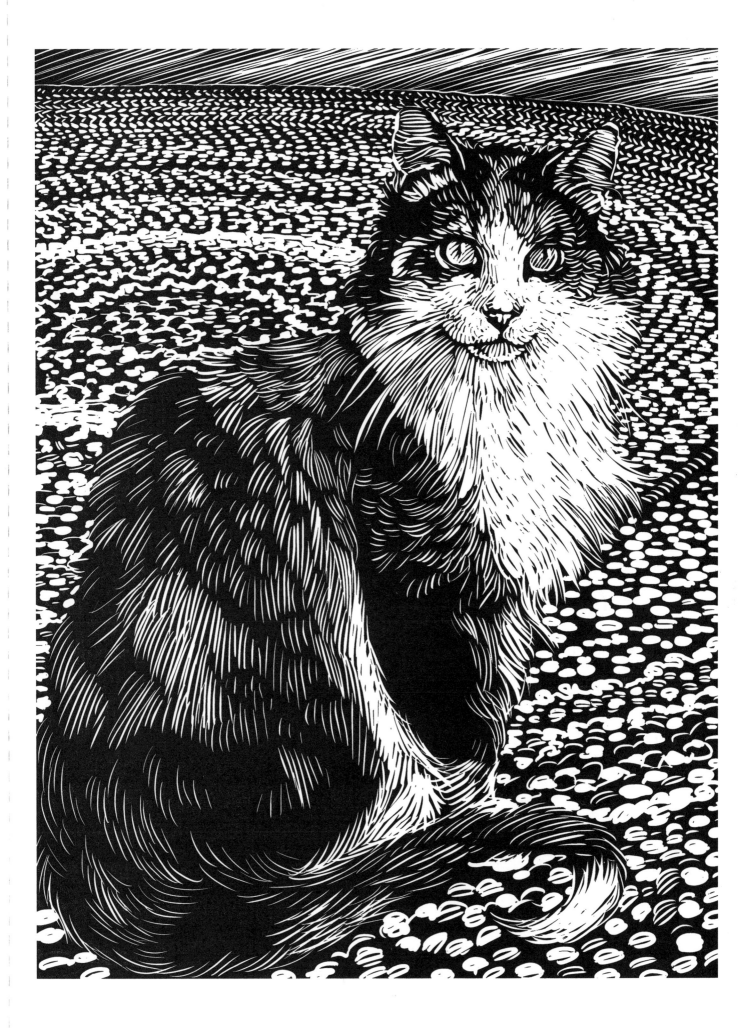

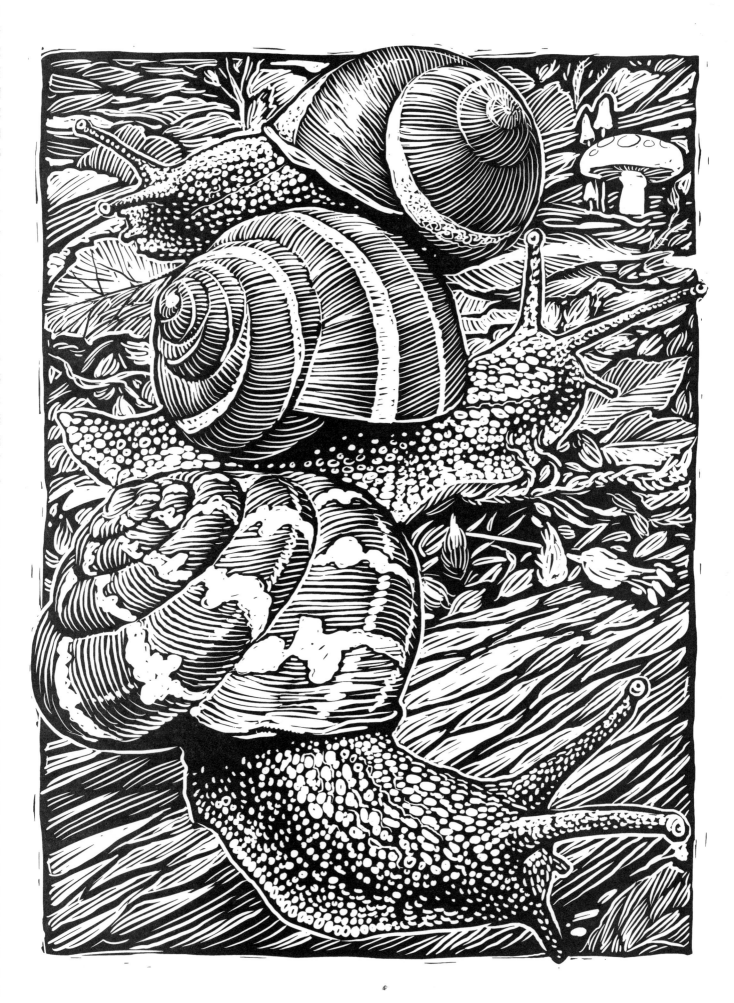

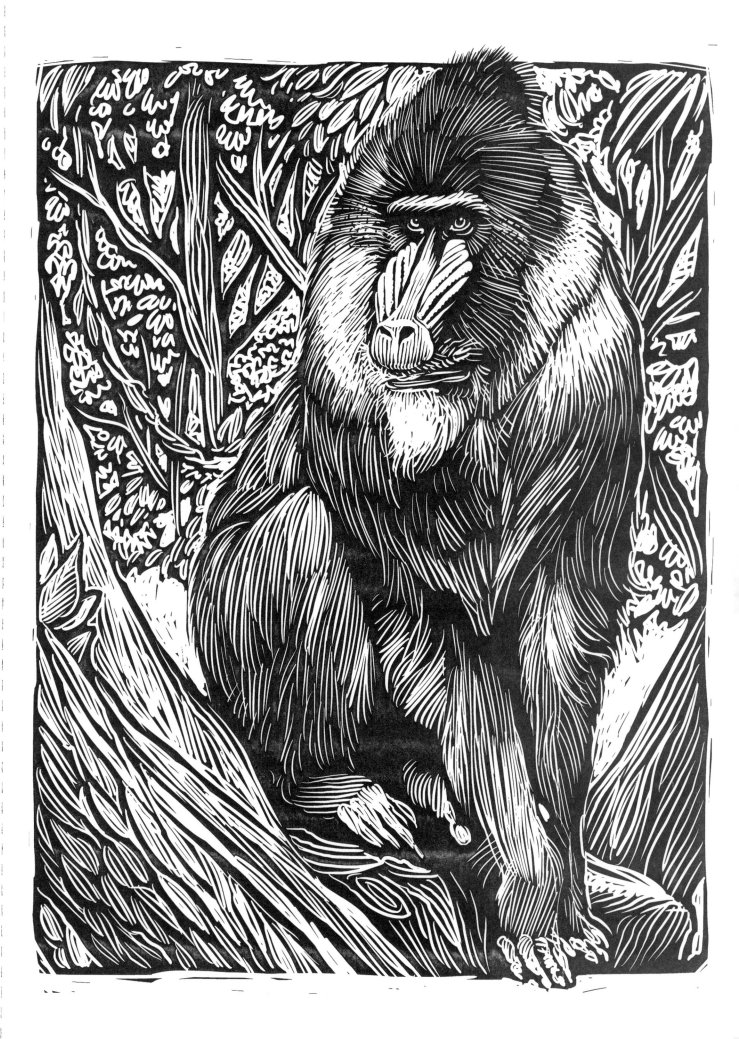

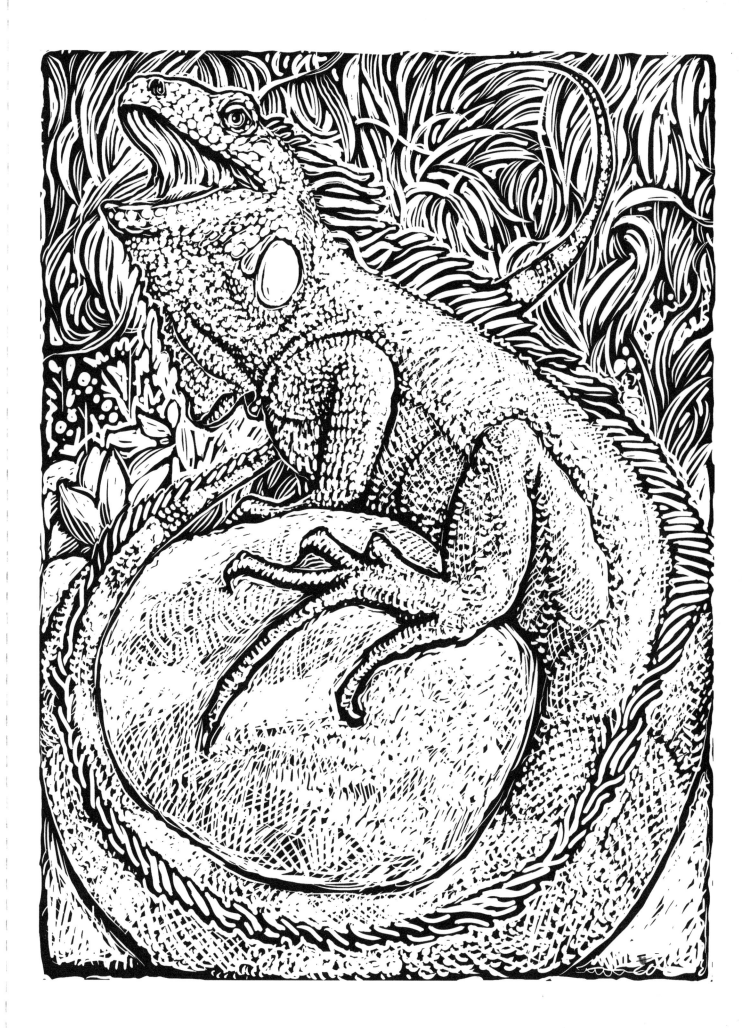

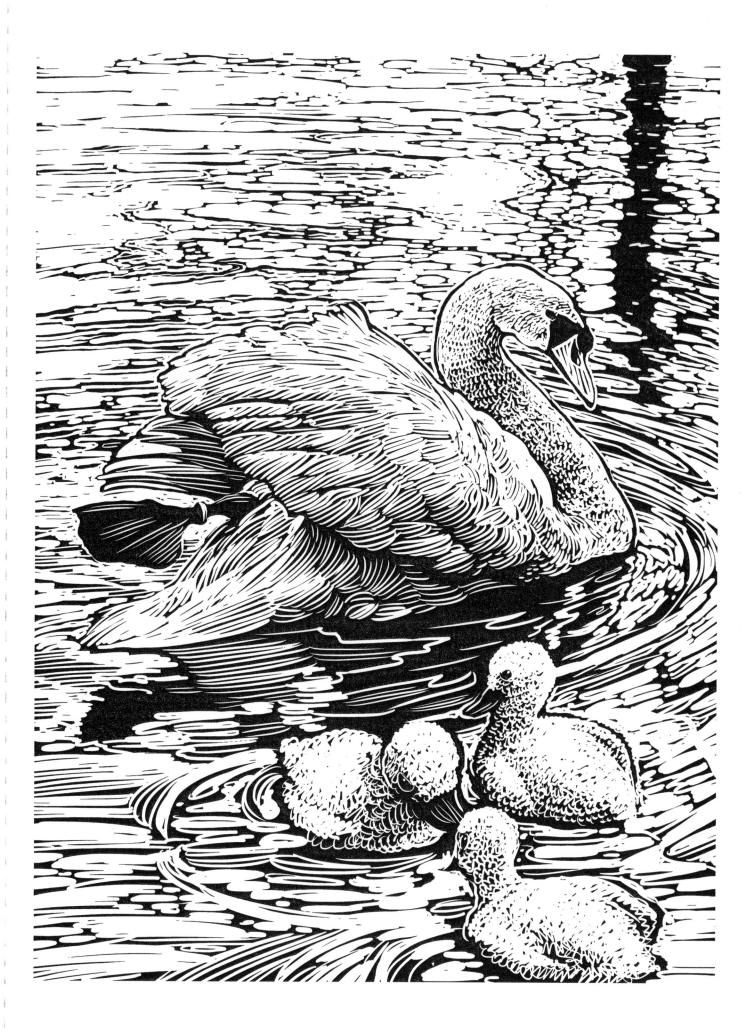

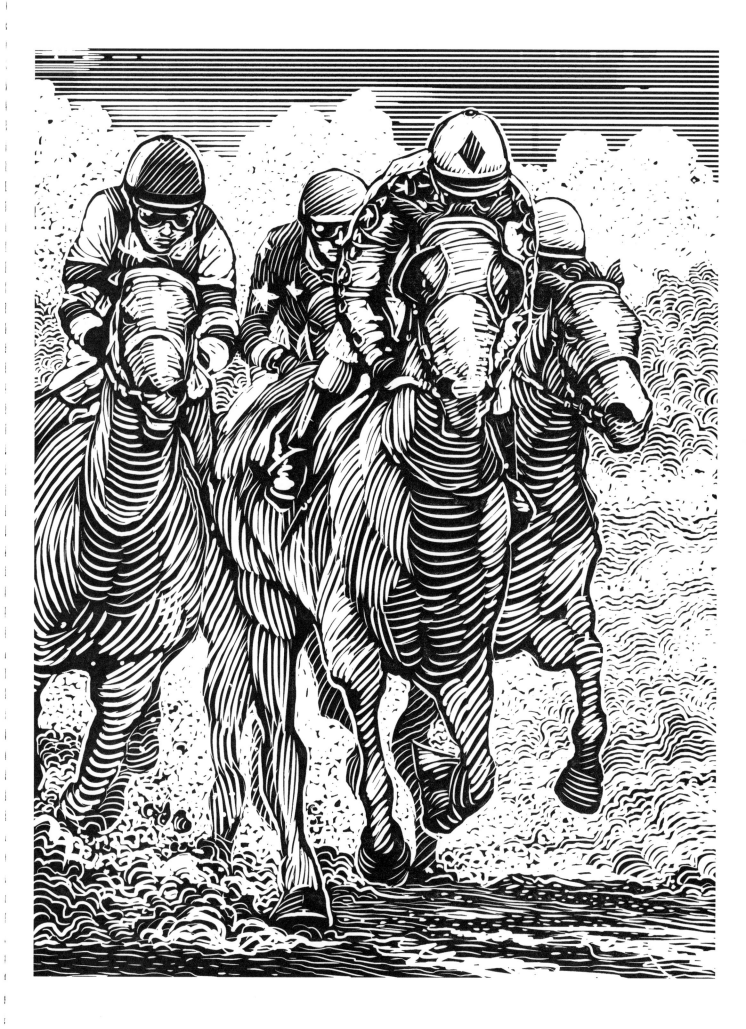

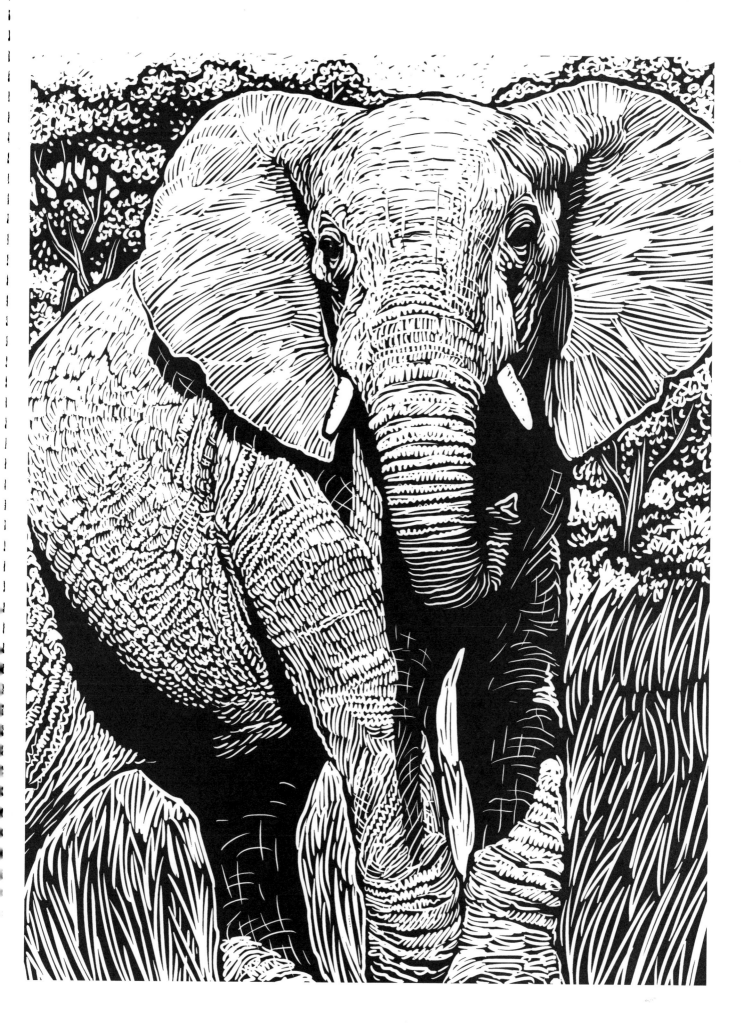

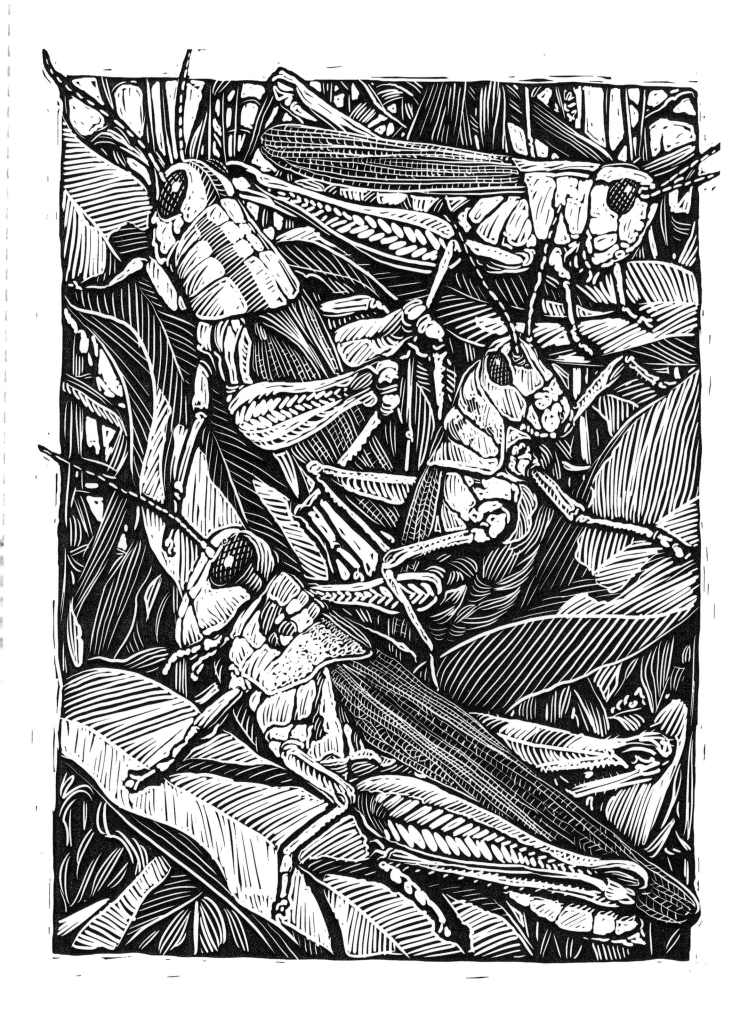

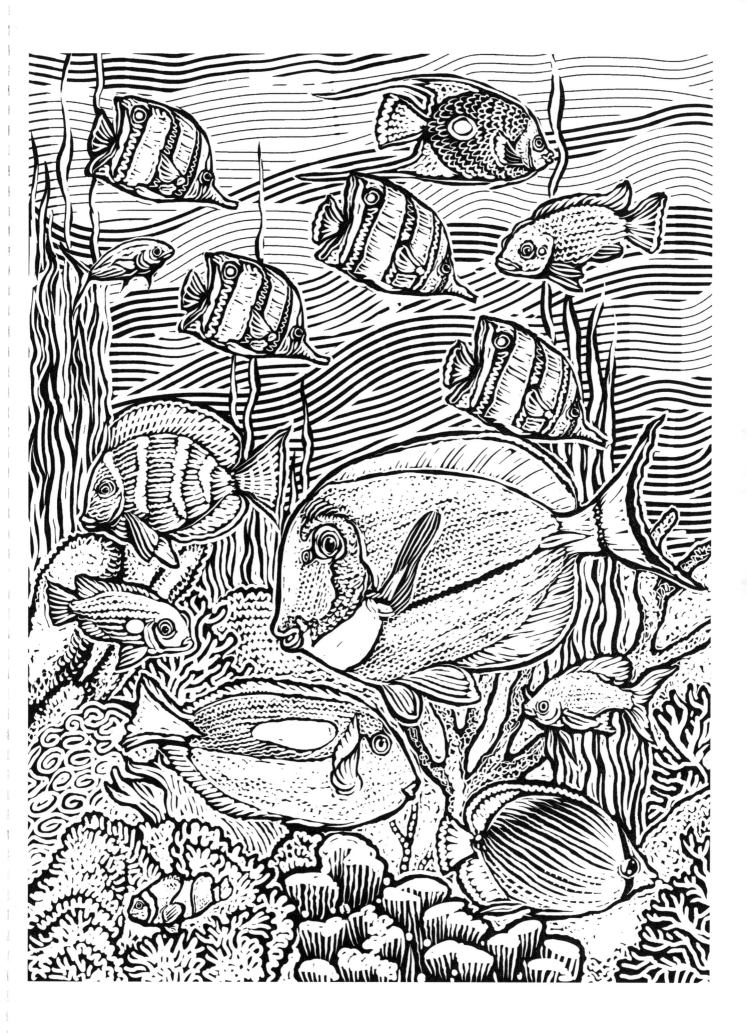

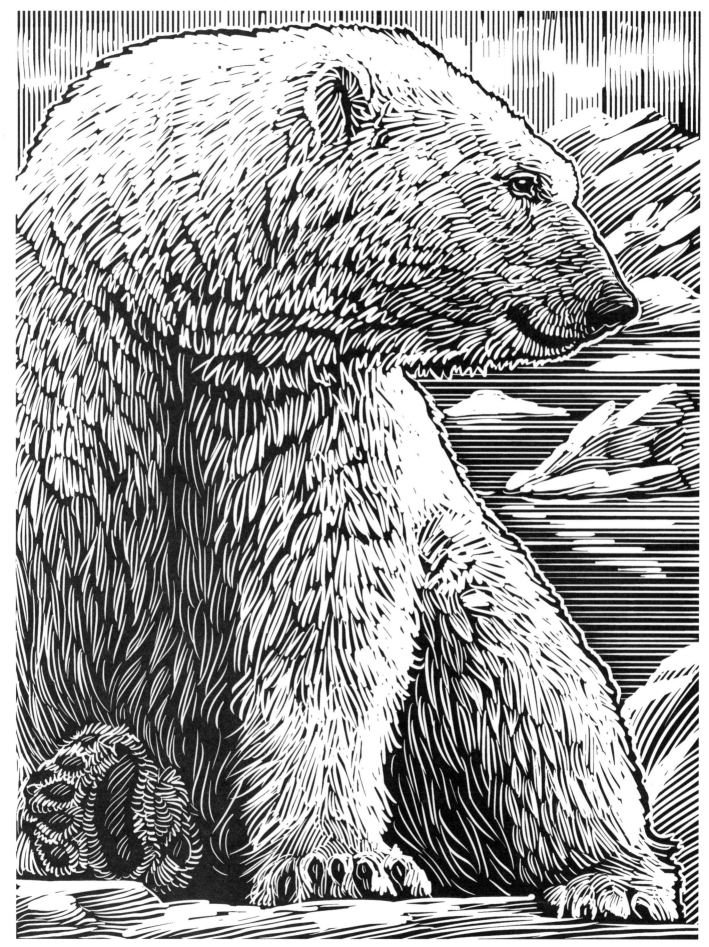

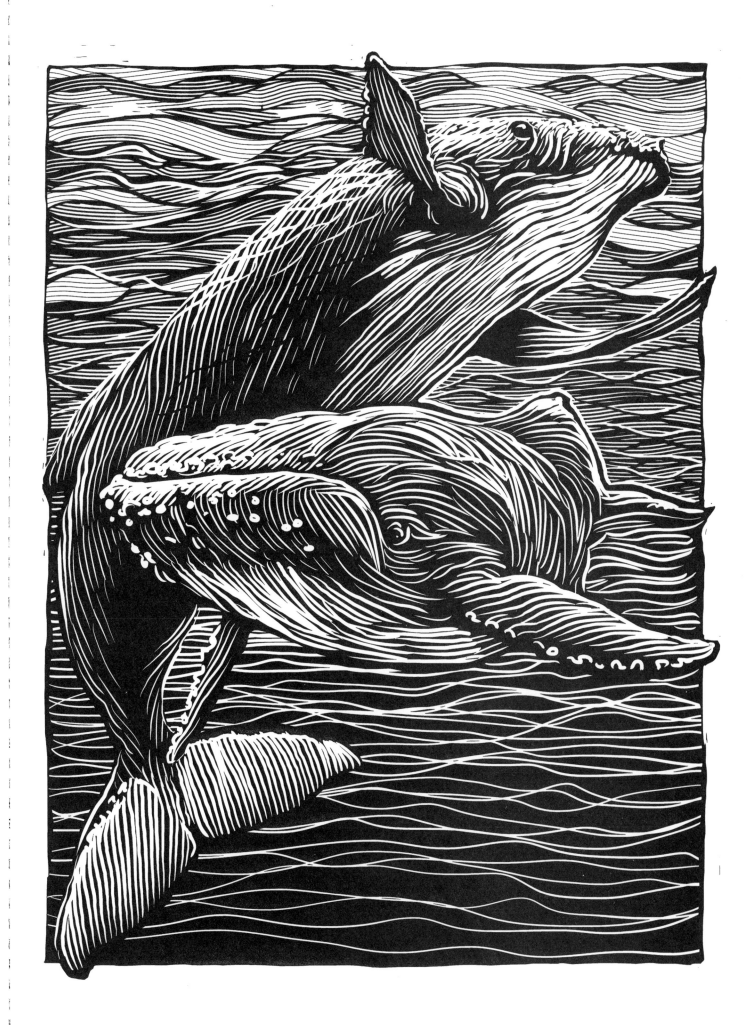

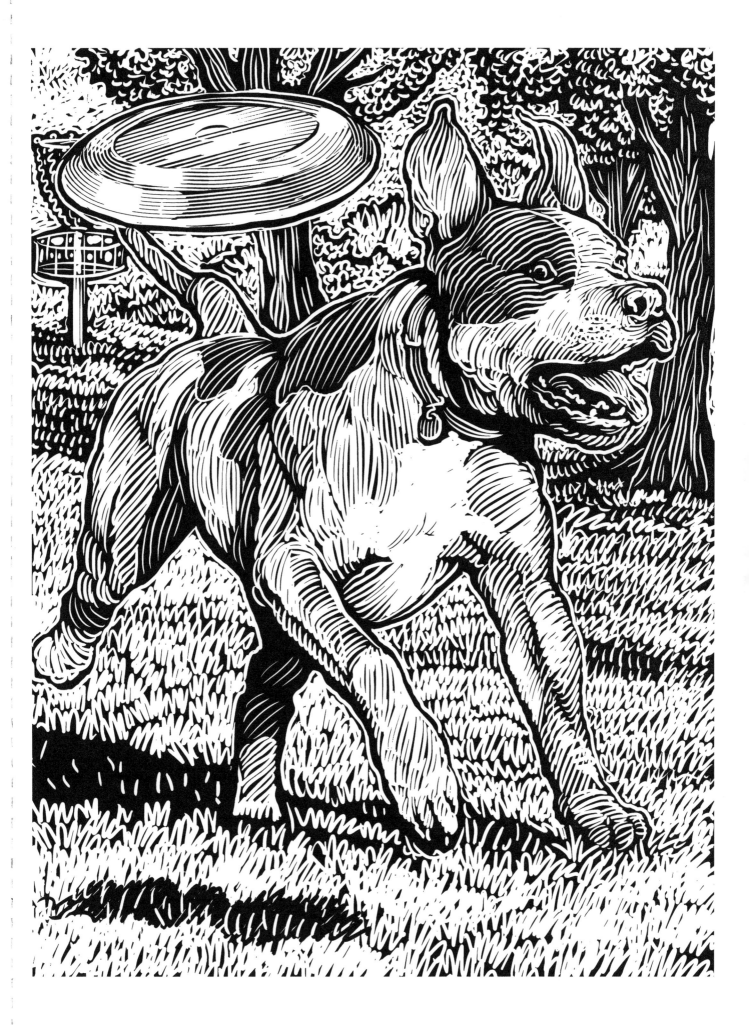

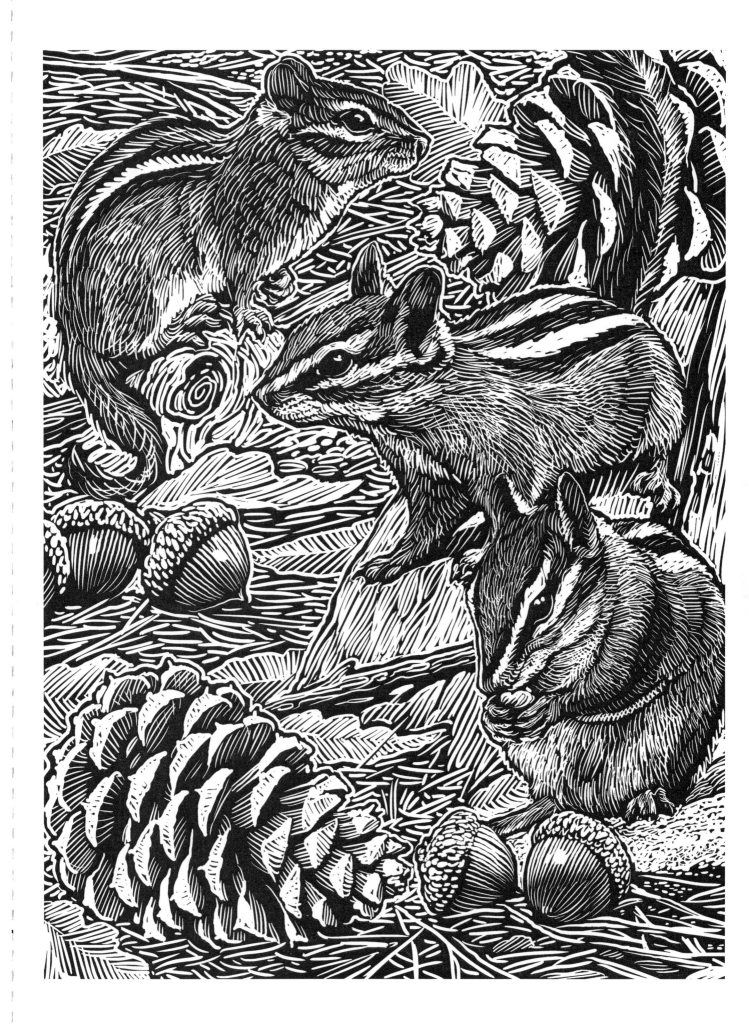

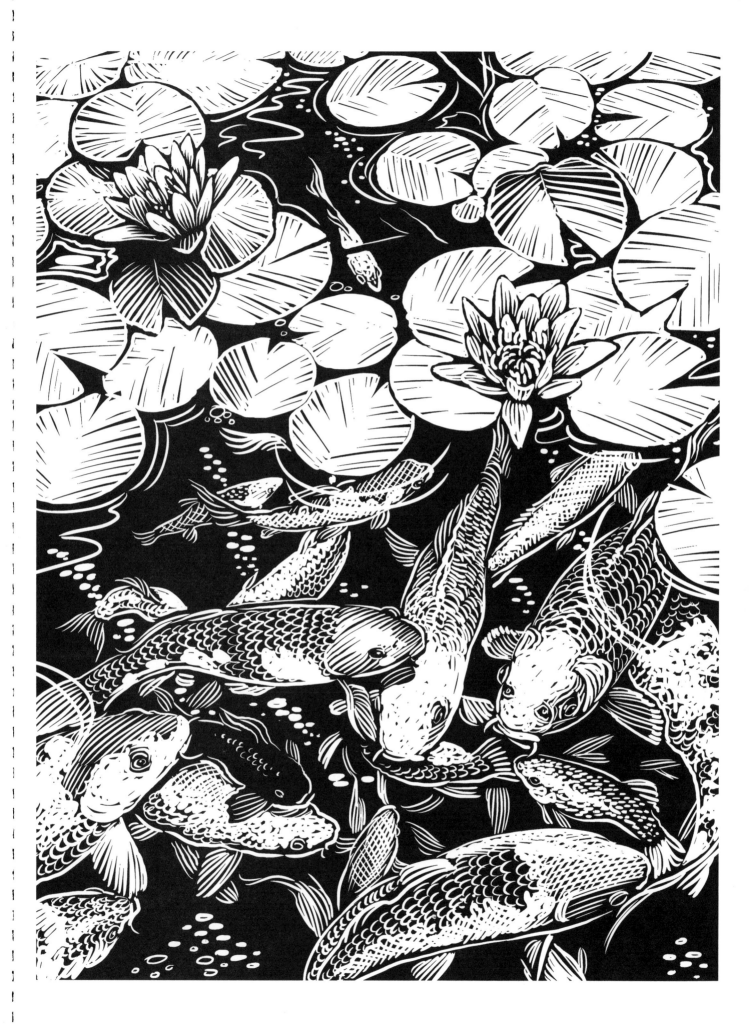

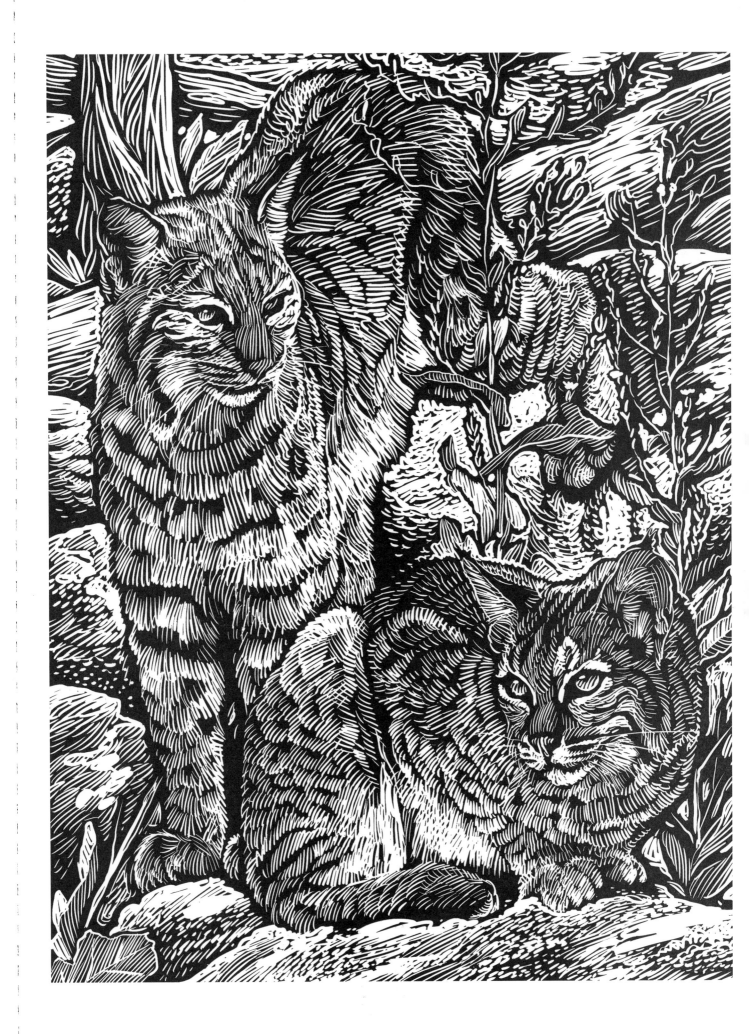

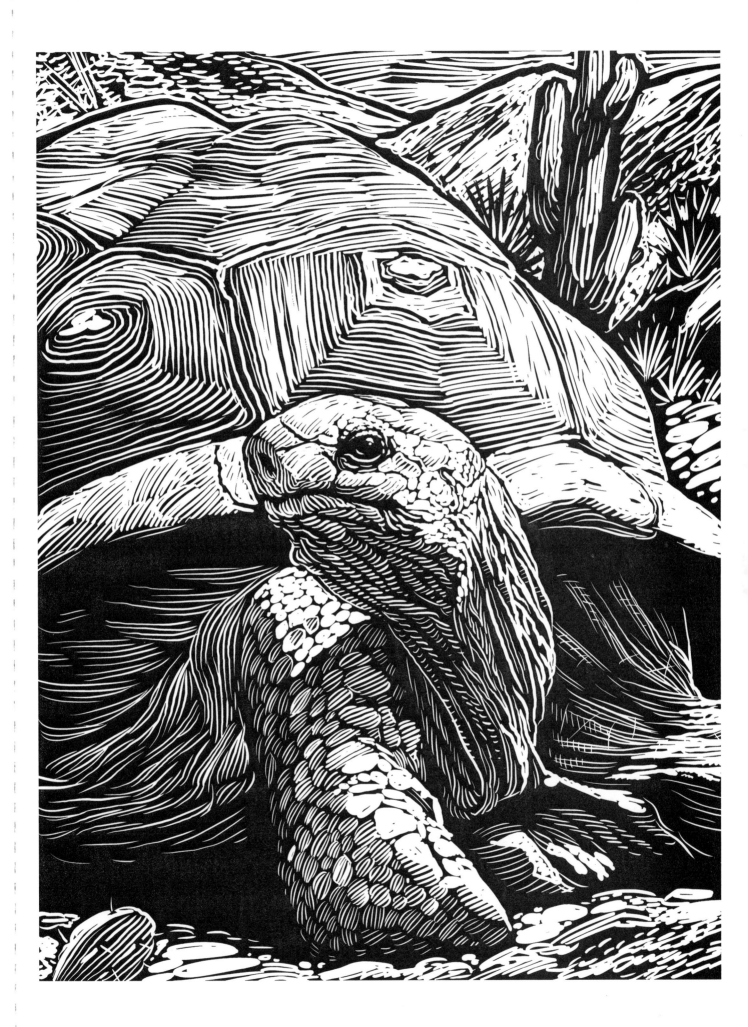

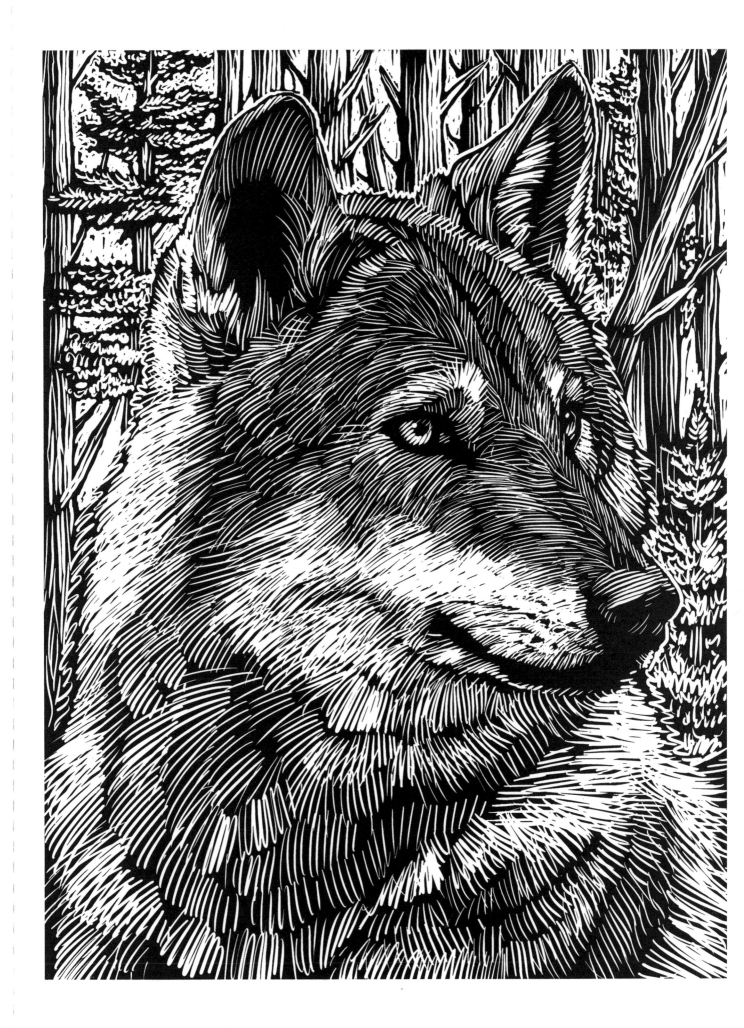

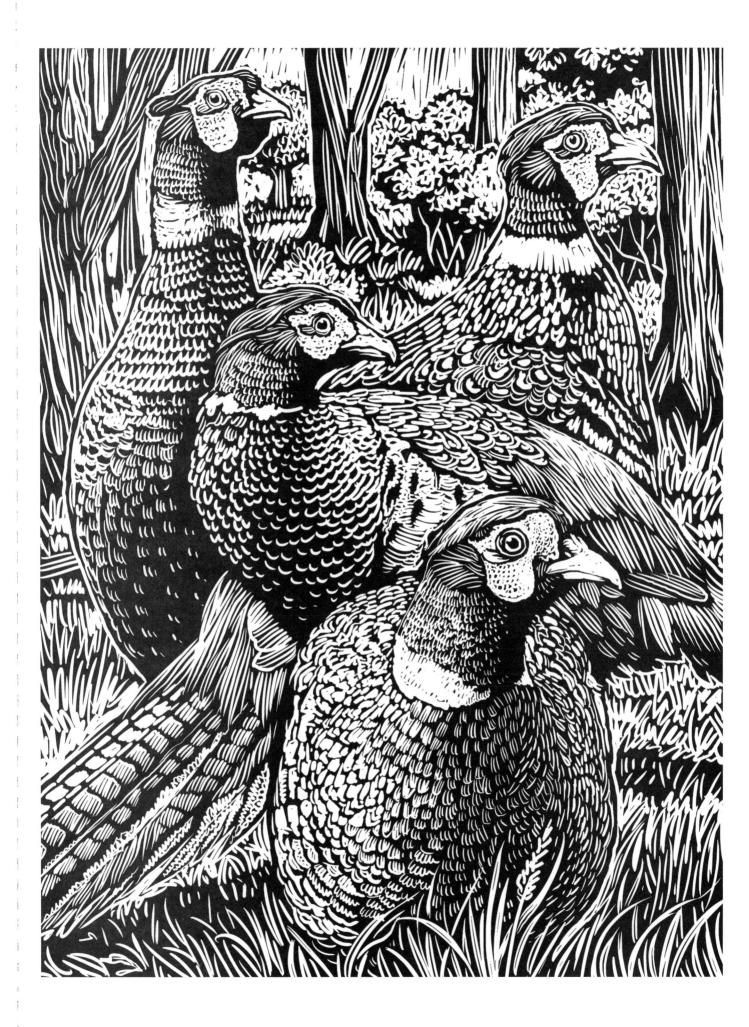

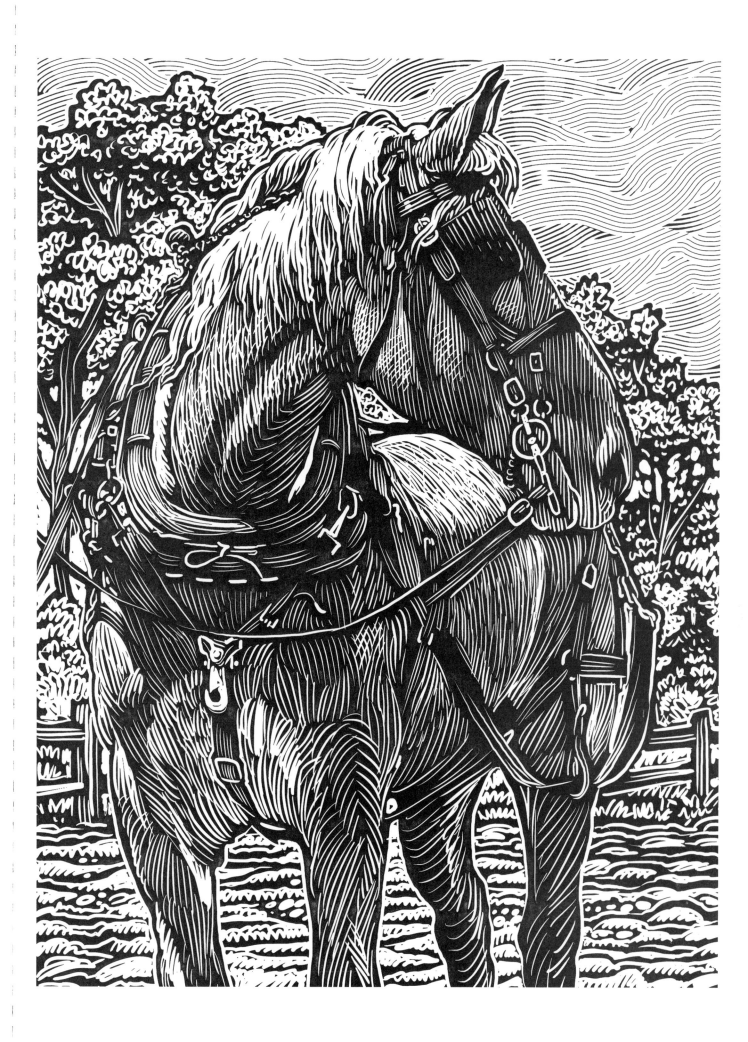

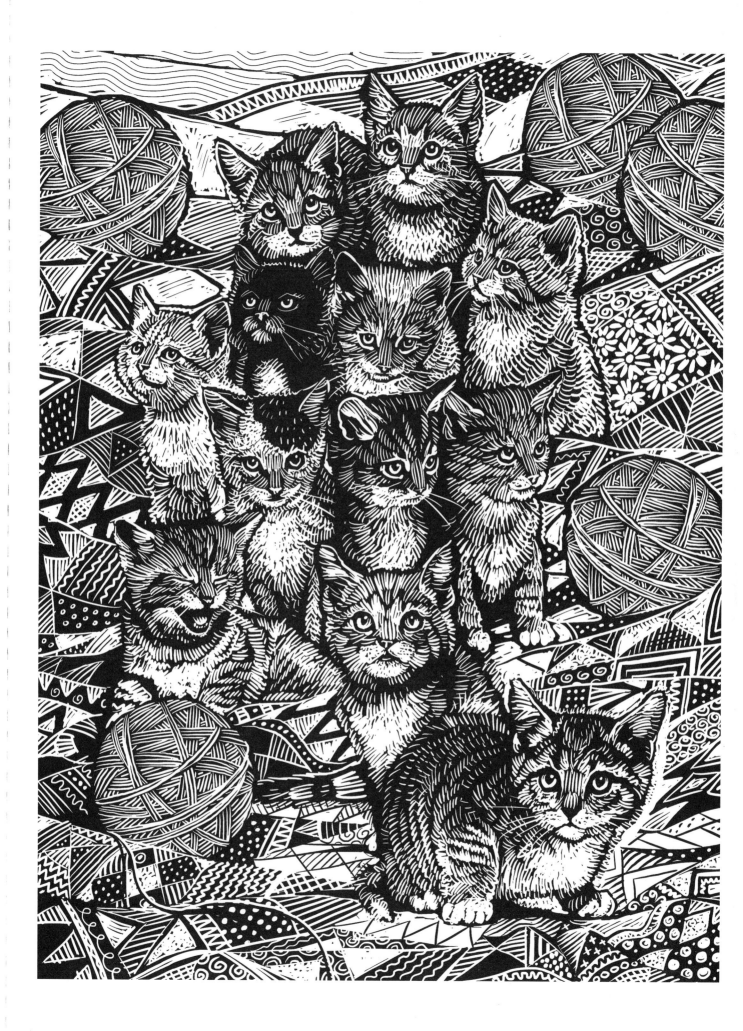

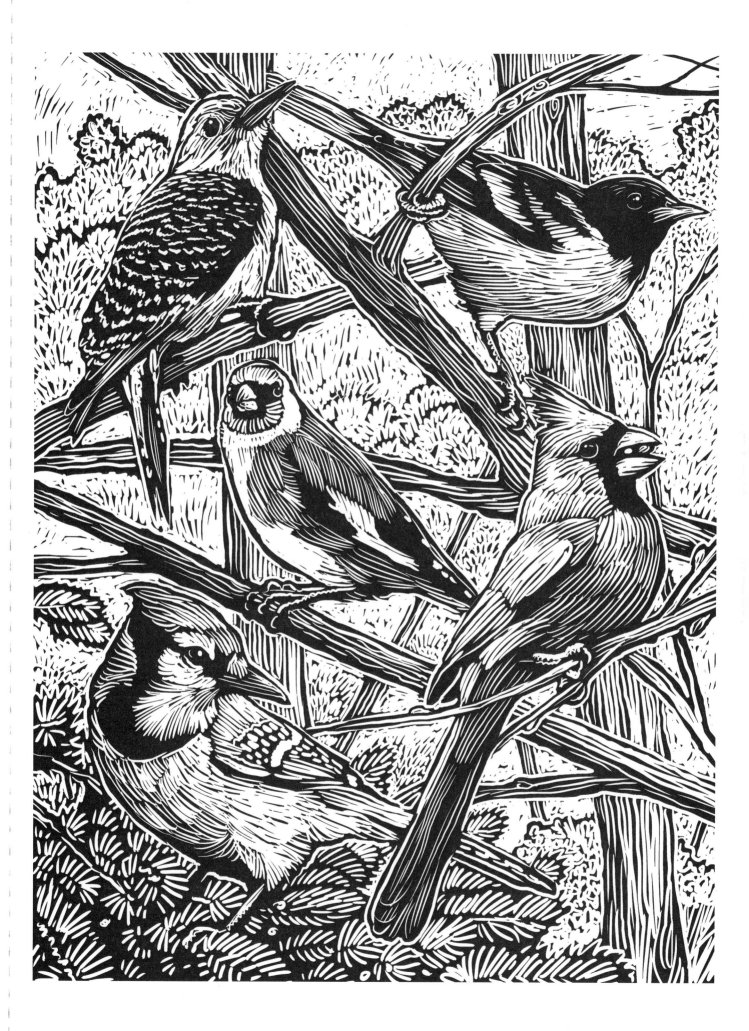

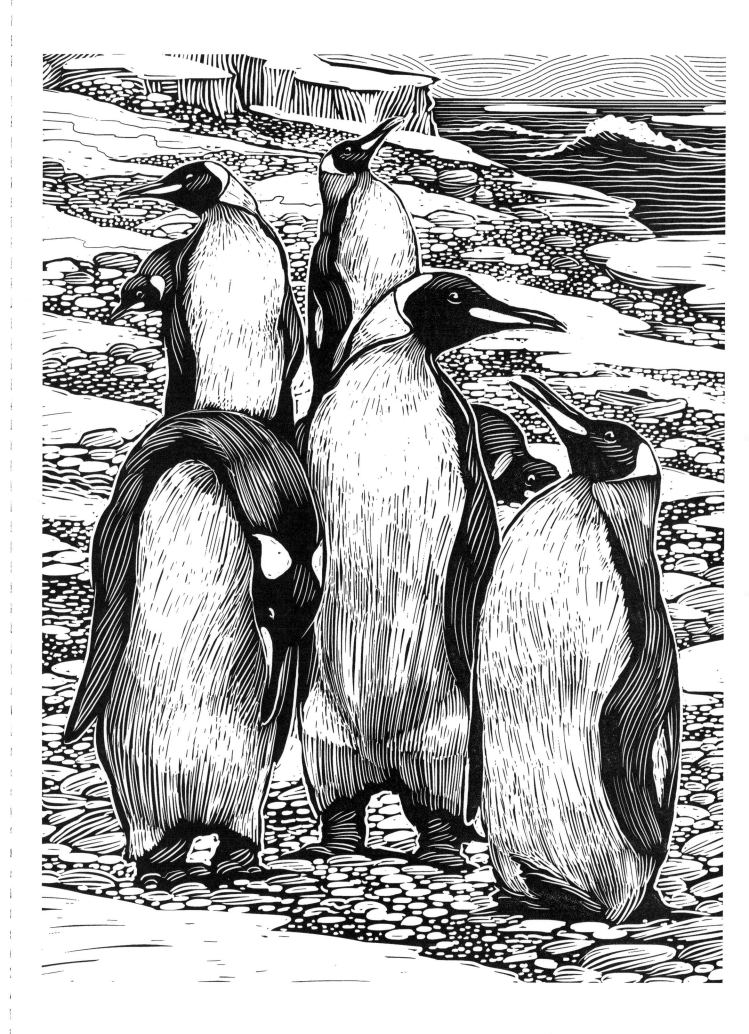